Summers of Discontent

Summers of Discontent

THE PURPOSE OF THE ARTS TODAY

Raymond Tallis
with Julian Spalding

WILMINGTON SQUARE BOOKS
an imprint of Bitter Lemon Press

WILMINGTON SQUARE BOOKS
An imprint of Bitter Lemon Press

First published in 2014 by
Wilmington Square Books
47 Wilmington Square
London WC1X OET

www.bitterlemonpress.com

ISBN 978-1-908524-409

9 8 7 6 5 4 3 2 1

Designed and typeset by Jane Havell Associates
Printed in the UK by TJ International, Padstow

Contents

Contents

Introduction
Julian Spalding

This book is an estuary pearl. It was formed when a river of thought about art and museums ran into an ocean of thinking about medicine and philosophy, science and literature. It is the outcome of a chance encounter in November 2010, when Ray Tallis and I met for the first time, during an hour-long taxi ride from Hereford station to Hay-on-Wye. We were both speaking at a conference, the brainchild of the filmmaker and philosopher Hilary Lawson which aimed to widen cultural debate after the Credit Crunch. Without Hilary's initiative, our paths might not have crossed. Ray and I had never heard of each other's work, but I was so interested in what he had to say that I soon buried myself in his books (at that time numbering a mere twenty-three).

I found myself in a cathedral of thought – a hymn to the nature of human consciousness. There were insights everywhere into all manner of everyday experiences, from crying to laughing, including an extraordinary, extended account of blushing, each describing the emergence of those impulses in the physical world of our bodies, and their expansion in meaning in the realm of our minds. One whole book is devoted to the significance of pointing;

Tallis claims it is a uniquely human ability, which presupposes that even stranger attribute, our collective consciousness. Amongst all this, I found many passages on the significance of the arts, all of them startlingly fresh in their approach.

Most of the writings on the arts of which I am aware try to explain their effect on us, taking as read the fact that art is created in the first place. Tallis hasn't written about art as an end product, but instead investigates why it is made, in much the same way that he would if he were exploring the origins of a laugh, a cry or a blush. In his view, the arts emerge out of what he calls 'the wound in the present tense of consciousness', most clearly expressed in our inability fully to experience our experiences. He gives many reasons for this but the most fundamental is the failure of any given experience to correspond to the idea we have of it either in prospect or in retrospect. This awakens a hunger – unique to humans – for a more rounded or complete sense of the world. It wasn't Tallis's intention to examine the arts in particular, but he found himself writing about them as part of his extraordinarily wide-ranging intellectual ambition to define what we really do and don't know about our state of being aware; more specifically, the distinctive nature of human consciousness. That's why his ideas on the subject are essentially buried within his works, particularly *Newton's Sleep* (1995), *The Explicit Animal* (1999) and *Hunger* (2008), with other fascinating insights scattered throughout his vast output.

My first thought was to encourage him to write a new book specifically about the arts, but then I realised that he'd already done it: the volume just needed to be excavated and compiled from his numerous texts. To his surprised delight, as well as mine, I set about this task. It's a tribute to the coherency of his thinking that his disparate insights make such sense when strung together. My role in this book has obviously been that of an enabler not a creator, but I

had the pleasant illusion, while involved in this task, of being almost an artist myself, as evoked in Goethe's beautiful image of the artist bending down to the flowing stream of life and lifting out a perfect sphere. The illusion is only there because the river of thought I've dipped into has been so clear.

There is an urgent reason for publishing this book now. Tallis's ideas address a pressing issue: what purpose do the arts have in today's society? In the past, artistic creation was generally in praise of gods or kings. In some cultures it still is, notably in Islamic societies, in Hindu India, and in North Korea. But in modern secular societies, the arts have no clear role. If, as John Ruskin said, all art is praise, then what do the modern arts praise? And if they don't praise, if they aren't positive and beneficial to us in some way, then what is the point of them? Is it their role to warn – and if so, why does no one listen to their warnings? But despite this lack of clarity of purpose, people have gone on making the arts, attending artistic events and teaching artistic subjects, and governments have gone on subsidising them (even when the artists are critical of them) because it is widely believed that in some undefined way the arts 'do us good', so much so that a society barren of them is held to be uncivilised.

Every city worthy of the name has to have its opera house, concert hall, theatre, library and gallery. The arts have acquired a quasi-religious status, hedged round by assumptions that one would be thought a philistine to question. Of course, the vast majority only pay lip service to them, as they once did to their state religion. It's enough that the opera house exists; people don't actually have to attend performances. Most prefer easy entertainment, so much so that it's quite possible that the opera house will go the same way as the church, as societies become increasingly dumbed down. If this happens, many believe that something essential will have been lost

– but what? Do the arts have a vital role to play in people's lives today, or are they merely the province of the educated middle classes, clinging to a worthy, mythic, antique raft that is about to sink under a tidal wave of vulgar, spoon-fed tat?

Tallis's ideas check this slide. The implications of his theories are, I think, immense. They could and should affect how governments subsidise the arts, how they're taught in schools and colleges, how we validate and analyse them, how we make decisions about what to preserve from the past and, even more fundamentally, how works of art are created. Tallis convincingly dispels the notion that the arts can do us any moral, social or educational good (so governments should have nothing to do with their content or creation), but then goes on to argue that, by virtue of being useless, they serve a vital purpose in helping us to cope with our awareness of the limitations of our existence, of living a finite life of incomplete meanings (so governments have a responsibility to give everyone access to them).

He makes the case that the arts are not the exclusive property of any elite, nor accessible only to the especially insightful. Even the most abstract art of all, music, which is not burdened with a fidelity to an external world, Tallis claims, 'pitches its bivouac in the chaotic littleness of everyday life'. So he undercuts all those purely formal aspirations that have, lately, led the arts down effete, self-indulgent cul-de-sacs, and he bangs the final nail into the coffin of art made for propaganda. Tallis has identified a purpose for the arts that is based on real rather than wishful needs, and which provides a firm foundation for their development and expansion.

His theory reconnects art to entertainment, for both spring from the same psychological hunger. At the same time, he raises our ambition for the arts to embrace our whole experience of life. This is an agenda for a new Shakespeare: to create works of art that are

both popular and profound. Stripped of any responsibility to improve our lot, and free to entertain and thrill in whatever way they like, artists will once again be able to be themselves, listen to their own voices and spread their wings.

Tallis doesn't give any indication as to what form these new arts will take. In his view, each work of art is a fresh expression of a moment more fully lived. Picasso said that the reason he painted was because he was unhappy. He also once remarked, 'If I knew what I was going to do today, why would I do it?' Life doesn't need to be a tedious repetition, a labour or, even, an endless holiday: it can be an adventure. This possibility of freedom is open to the artist in every one of us, whether we are creating artworks ourselves, or choosing which art forms we want to enjoy and explore. For the surprising and hopeful implication of Tallis's simple and beautiful observations is that our massive collective discontent, which has the potential to destroy the planet, could be transformed, by our own agency, into a massive collective benefit.

Man and Animal

We know much less about the nature and the origin of consciousness than we think we do. Consider, for example, our ability to see. Seeing is so closely related to our awareness that the phrase 'I see' also means 'I understand'. The evolution of sight, the transition from a sightless creature to one which has something like a recognisable eye, represents a long journey across genetic space. Many thousands of mutations are required. Biologists (such as Richard Goldschmidt) have claimed that, since the first few thousand mutations would confer no advantage, the organisms affected by them would not enjoy preferential survival. And this would seem to suggest that the long journey from sightlessness to vision would not be likely even to begin unless all the necessary mutations took place at once – an event that has a negligible probability. Richard Dawkins has reminded us, however, that even the smallest steps towards an eye might have conferred advantage: most obviously, a single photo-sensitive spot on an organism's surface would give it some kind of edge over the competition. A gradual evolutionary journey towards eye-hood is therefore possible. Even so, something

fundamental remains unexplained. An ever more complex photo-sensitivity correlating with salient features in the outside world and regulating and fine-tuning behaviour makes evolutionary sense; but there is no reason why that photosensivity should be conscious; why the eye should see, in the sense of understand.

The questions that hover around the evolution of the eye are nothing compared to those that haunt the more general question of the evolution of our minds. Consciousness has always been an awkward customer for biology – and evolutionary theorists – to deal with. Samuel Butler complained that Darwin's theory 'banished mind from the universe'. What he meant was that it removed not only the need for a purposeful Creator to explain the origin of the species but also intention and purpose from the entire evolutionary process. This hasn't worried many biologists, for whom it is a positive virtue of the theory. But it does make it rather difficult to find a place for mind, or consciousness, in the scheme of things.

Consider the extraordinarily complex ordering process that is associated with crystallisation. Would a solution of copper sulphate produce better crystals if the individual molecules knew what they were about, if they got together and defined their aims and objectives? Of course not. It might be objected that the analogy is not fair, because the crystallisation of copper sulphate is not a conscious objective whose realisation is to be carved out of natural process. But since, according to evolutionary theory, the universe from which consciousness emerged was that of unconscious and purposeless matter, in which there were no conscious processes, the analogy seems perfectly fair. So we cannot explain the emergence of consciousness on the basis of the needs created by the adoption of conscious purposes.

Are we entitled to envisage consciousness emerging in the same gradual fashion as the eye as a result of the operation of natural

selection on random change? At first sight it would seem so. One could imagine a long evolutionary journey, a Great Trek across genetic space, from the 'low cunning' of the potato in the dark cellar (or *E. coli* in some even darker place) to the much higher cunning of the fully conscious human being. But *is* consciousness a property, a feature of organisms that can emerge gradually in this way? Can consciousness come into being in the piecemeal fashion of organ systems or plumage? It seems that there is a clear difference between consciousness (or mind) in this respect and life, which *can*, it seems, many scientists now think, come into being by degrees. Consciousness is either there or not: you can't be a little bit conscious any more than you can be a teeny-weeny bit pregnant.

Moreover consciousness doesn't necessarily confer an evolutionary advantage, though we hopefully – a better word might be vainly – tend to assume it does. It is a common observation that many procedures that can be carried out automatically may be performed less efficiently, or indeed break down altogether, if the subject tries to enact them deliberately, consciously executing each step. Consciousness has to be kept in check if the many activities of daily life are to be accomplished with the requisite expedition and fluency. It is an equally common observation that, as a skill is acquired, mechanism increasingly dominates over conscious and deliberate action. A learner driver at first specifically addresses himself to the tasks of changing gear, keeping the car in place by moving the steering wheel, braking when instructed, etc. The experienced driver no longer does these actions separately and deliberately but simply drives himself from A to B. It is possible to find that one has driven fifty or a hundred miles along a motorway without being able to recall 'doing driving' at all – the so-called 'time-gap experience'. This emphasises the way in which skilled behaviour is hierarchically organised, so that its components become automatised. Conscious-

ness-driven activity emerges out of background driving only when the unexpected happens – for example, a sudden obstacle has to be avoided – although even in such cases appropriate responses have often been initiated before conscious decisions have been taken. Conscious intervention in acquired skills may be a necessary preliminary to further improvement; apart from this, however, it is the road to paralysis, to the inhibition that results from a dysfunctional self-consciousness. Hamlet's awareness made him dither.

A good deal of conscious behaviour – hobbies, loving people as well as lusting after them, creating and enjoying art – and many of the uses to which consciousness is put (such as speculating about the origin of consciousness) seem to have little to do with survival in any but the most tenuous or metaphorical sense. Indeed, much of conscious human behaviour even in the undeveloped world, and certainly in the developed world, is concerned less with survival than with happiness or satisfaction. The pursuit of knowledge far exceeds the seeking out of information necessary to satisfy physiological need. It is as though consciousness, if it had originally developed to help us to avoid tigers and catch cows, has gone out of control so that it now allows (or drives) us to enjoy reading philosophy and talking about music, and to try to make a more complete sense of our origins and destinations by, for example, constructing theories of evolution.

It is difficult to believe that such an 'exceeding of its brief' is purely accidental, or even that it is merely secondary; on the contrary, it seems closely related to the essential nature of consciousness. Conversely, the evolutionary view of consciousness as a mere servant of adaptive behaviour, a mere instrument of survival, something that serves a particular, defined purpose, seems to be untrue to the facts of everyday experience: we are conscious of much more than is expressed in our behaviour and there are many forms of con-

sciousness for which there is no behavioural expression relevant to survival.

And there is the problem of the distinctive nature of human consciousness. The relationship between human and animal faculties may be captured by imagining the animals fighting their way through a wilderness near to the beginning of a motorway that humans are travelling along at sixty miles an hour. The animals may move in the wilderness parallel to that motorway for a few yards but cannot drive on it. With a few exceptions, each generation of animals, moreover, begins at the same point in the wilderness as the last and there is no cumulative progress – not even painfully slow progress – except in so far as the animal's body changes over vast periods of time. The power of making explicit, the explicitness inherent in human consciousness, is what makes motorway travel possible for humans and lack of it that denies animals such travel. The analogies between human and animal faculties deceive us into thinking that we and they are travelling along the same road, that they are on the same road as us, only further back. In fact, animals are not even on the road; only at a location corresponding to a point just beyond the beginning of the road. Thus the relation between animal tool-using and human technology; or between animal communication and human language.

This account of the difference between man and animals leaves the relationship between them deeply puzzling and the transition from the one to the other almost inexplicable. There is a difference not in degree but in kind between animal tool-using and human technology and between animal communication and human language. Ought I to apologise for this failure to accommodate the evolution of consciousness into the evolution-of-bodies story? Not at all. It is better to have an unsolved problem than a false solution.

*

In the classical country house, the park or garden is separated from the countryside by a Ha-Ha. Essentially, it is a trench: on the side nearer to the house it is perpendicular and faced with stone; while the outer side is turfed and slopes gradually up to the original level of the ground. The most important feature of the Ha-Ha is its near-invisibility from within the house. It permits an unobstructed view of the countryside – hence its alternative name, *claire-voie*. From the house, the fields appear as a simple continuation of the park. This is, of course, deceptive. For the Ha-Ha presents a formidable barrier to sheep and cows and other animals that might wish to enter the gardens and graze on the prize roses or trample through the kitchen garden. Moreover, it is a potential hazard to human beings, who might easily overlook it, as is indicated by its name: those who observed it said 'Aha!' and those who did not caused their friends to say 'Ha ha!' when they fell into. According to most commentators, the Ha-Ha symbolises the boundary dividing human Culture from Nature, the domesticated house and garden from the wilder country beyond. It is possible also to see it as a rather precise metaphor of the invisible but very real divide between man, the explicit animal, and the rest of the living world. The non-human animals cannot cross this barrier; and those thinkers who do not observe it, who fall victim to the illusion of continuous ground between Nature and Culture, are destined to drop into it.

I commend this metaphor to all those who look to a return to animal knowledge and instinct, or to primitive wisdom, as the way out of what they perceive to be 'our present dilemma'. I would also commend it to anyone else who might be tempted to denigrate human Culture as a deformed or unsatisfied or dangerously suppressed version of the animal Nature. If there is such a thing as The Human Predicament, and if it makes sense to offer any kind of treatment for it, I suspect that the prescription would take the form of

more, not less, explicitness; of capitalising on the advances that we have made, rather than falling back into the instinctive world of primitive man, of hominids, or higher primates. The major challenge of the next millennium is not to return to our animal selves, but to deal with and perfect our knowledge. We cannot solve our problems by returning to, and perfecting, a nature we never had.

Summer of Discontent

For over ten years we have holidayed in the same place: the same rented cottage in the same Cornish village. This is not through inertia or because we can't afford to go to Spain but out of a positive decision not to change a winning formula. After our first visit, we said we wanted to come back every year forever. With Cornwall I associate some of our happiest hours (as well as one or two unhappy ones) and the afterglow and foreglow dominate the rest of the year. At any given time, I am a certain conscious distance from our Cornish holiday. We often refer to it; the family album is dominated by Cornish photos; and my study is cluttered with memorabilia of the village and cottage where we stay.

The outward journey is a relay of landmarks and the successive holidays are themselves, increasingly poignantly, landmarks. They have charted the growth of our children: the development of their interests from (say) the movements of slugs under stones to the tactics used by tank commanders in the Russian campaign; and their changing awareness of time – from the shoreless, unformatted, innominate days of infancy to a mapped-out year which gives habi-

tation for hopes and worries about events months ahead. They have marked the changes in our careers – in my own case from a humble junior doctor to an (of course) equally humble but better-paid professor. The holidays, in short, are an instrument for revealing the slow, large-scale changes in our circumstances, a series of frames in a time-lapse video of our lives.

And so each year, we look forward to that magic, climactic moment when we *arrive* in Cornwall, *arrive* in our holiday. And therein lies the difficulty. Increasingly – and we adults now acknowledge it openly and my diary has discussed it for some years – we note the lack of an absolute sense of arrival. And this despite the fact that every holiday is in many ways better than the last, fulfilling our intentions more precisely. To anticipate: we have an insufficient sense of being on or in the holiday we had imagined or looked forward to; as if holidaymaking demands a sharper, more continuous, more specific, sense of being here and being of ourselves and this sense is denied us.

The feeling of insufficiency takes various forms. The most obvious and illuminating is *our inability to determine the precise moment at which we have definitely arrived* – after which we can confidently say, 'We are here. The holiday has begun.' Is it when we cross the Tamar and know that, geographically, we are in Cornwall? When we read TIREDNESS KILLS TAKE A BREAK and Mrs Baggit tells us to look after Cornwall and take our litter home? No, we are still fifty miles from the cottage. Is it when we first see the sea? There are quite a few miles of narrow lane yet to go. Besides, you can't do anything with the mere sight of the sea. Surely, then, it is when we first reach the cottage. But there is so much unloading to do and pressure to do it quickly before our illegitimately parked car becomes a road block and our arrival is celebrated with official fines and/or unofficial abuse. Unloading – decanting possessions in large blocks –

passes over into unpacking: distributing individual items. Putting a particular pair of underpants in a particular drawer, or discovering that a treasured toy or an essential gadget has been forgotten, is hardly arrival. Manifestly not: it is too much like housework, too detailed and too interior, and faces too decisively away from the sea. And, in the early years, too fraught to be holiday-like: the hasty distribution of effects was shadowed by an anxiety that, when our backs were turned, somebody would discover a way to fall down the ungated stairs or off a wall.

What about when we first go into town to buy provisions – and find that the general store is not so general as it used to be? This, surely, is a way of being arrived: renewing acquaintance with the village and the villagers (fewer of whom than expected remember us from previous years). No; for it is a journey and circular to boot. Moreover, the children's impatience tells us that it is only a preliminary. They have unnegotiable ideas about what shall count as arrival. Our holiday hasn't begun until bared feet have touched sand.

And so, in an endeavour to arrive as quickly as possible ('weather or not' – the annually re-dusted joke), we prepare for the beach. We pack food, drink and toys, and clothes for all contingencies – a wide range, given that the evolution of British weather is a classic exemplar of chaos theory. At last, oppressed by the weight of our possessions, we arrive on the beach. We find a suitable place: out of the wind, not so close to the sea that the tide will soak our sandwiches, nor too near to the youths with the ghetto blaster or the topless teenage girls braving the non-tropical Cornish air. The windbreak is erected, our mallet adding to a chorus that simulates the forging room in Nibelheim. We spread out our possessions. We sit down on the blanket, already covered with sand and spilt coffee, exchange smiles and prepare to subside into stillness. But not for long. Someone's spade has been forgotten and a packet of football

stickers has mysteriously disappeared. Several additional journeys are required to placate a child's grief. And numerous further adjustments – of the position of our camp, of the direction of the windbreak, of the distribution of our bits and pieces – are also necessary. Eventually, everything is in place.

Have we now at last arrived? Not at all. Even leaving aside the cloud that is homing in on the sun like a heat-seeking missile, we know that it is not enough merely to be touching sand. A *game* must be underway. Cricket, for example. So up we get to define a pitch, to put in whatever stumps have survived the journey, assign individuals to teams and try to resolve without recourse to the European Court of Human Justice the dispute over who is going to bat first. This, surely, is the moment of arrival: awaiting with bat in hand the ball which will be hit so hard that it will land in the sea. Or is it? Even when you are playing cricket, even when you are the privileged one with the bat – a minute portion only of the time devoted to the game (a much greater proportion being spent chasing after the ball that someone else has hit or missed) – you have to wait: for the bowler to get the ball, and to complete his run up to the stumps. There is more waiting when you have missed the ball and there is discussion as to whether you or the inattentive wicket keeper should chase after it. And when you have hit the ball, and almost score what looks to you like a six, you are rewarded with more waiting – more motionless journeying towards an ill-defined goal. The entire argument is symbolised in the fact that the moment the ball finishes coming towards you (and it has been on its way since the holiday was first dreamed about), it starts its journey away from you. The arrival between the journey towards and the journey away is the infinitesimally brief moment of contact between ball and bat.

Perhaps this is the wrong model of arrival. Isn't *doing* things on the beach – even archetypal, much-looked-forward-to things – a

way of losing the beach, and of losing sight of, and so failing to be arrived in, Cornwall? (Even though the sense of being here in Cornwall is fed from time to time by glimpses of the familiar headland beyond the endless adjustments of the rules necessary to ensure both ludic justice and a uniform distribution of happiness.) Is there not an alternative (adult) model in which arrival is the achievement of a certain passivity, rather than engaging in a specific activity? A more genteel version which requires a bit more negative capability than an often-contentious game of cricket? Isn't arrival really a matter of sensation; for example, the first time you feel the breeze on your bare legs (bared more in response to a sense of occasion than to meteorological realities) or the wet sand under your shoeless, sockless feet?

The trouble is, you are obliged to enjoy these sensations *en passant*. Correspondingly, not arriving increasingly takes the form of not being able to focus on them; in particular, not being able to greet, and pay proper attention to, the sea. The endlessly postponed moment of arrival becomes the moment *when you first look properly at the sea*. Early attempts to lose yourself in the vastness between the foam around your toes and the remote horizon will usually be frustrated. For example, you will be accompanied by someone who frames your contemplation within his handtugging impatience to get to the souvenir shop. In pursuit of this latter aim, he announces, as you remark the spindrift blown off the collapsing backs of the waves, that he needs to go to the toilet. The waves crash on to a shore other than your consciousness.

A couple of days later, however, one of the adults gives the other an *exeat*. One of you is at last alone with the sea. Even though contemplation may be clouded with the kind of preoccupations that comparative peace brings to the surface, this seems at least a nod in the right direction: definitively to arrive is to be engulfed in the

distinctive sensations of the place you are arriving at. But still you are not satisfied. It is not enough merely to dandle the sea at the distal end of telereception. To be fully arrived, you must be *engulfed*. This requires actual immersion.

Journeying is therefore resumed: a change of clothes; a long walk across the beach; and an inch-by-inch, sensitive-part-by-sensitive-part, entry into the water, negotiating past the shocks of cold that still, after all these years, retain their power to shock. The inaugural dip seems less arrival than a tribute paid to tradition and expectation. As soon as you are in, you are thinking about another journey: getting out and a version of arrival that includes dry towels and the sun in a sheltered spot behind the wind break. Quick in and quick out and, all duties and arrangements suspended, giving yourself up to the absolute comfort of solar energy.

The stretch of blue sky seems large enough for you not to have to worry about the return of wind and cold. You lie back and close your eyes. Your lids and the world turn to dazzled orange. The warmth on your arms penetrates beneath the skin. The contingent sounds that fill the 360 degrees solid angle around your repose – the voices of the children, the noise of the sea whose bruit between the waves has the continuity of an overheard motorway, the thud of mallets and footsteps transmitted with a curious metallic resonance through the sand on which your head is resting – mingle with the multi-dimensional dance of your thoughts. Assuming that there are no extrinsic obstacles to giving yourself up to the sun – such as a football landing on your stomach or a piercing cry of woe from one of your children – or a half-extrinsic one – such as some leftover worry or shred of resentment or the feeling that you ought to be doing something else – do you then, at last, arrive? Consider what happens next. Is it not typically the case that at such a moment all the year's fatigue gathers up in you and demands satisfaction, that

you willingly accede to these demands, and that you dissolve into *sleep*? And that when, an hour or so later, you wake, the world has a greenish tinge, it doesn't look like Cornwall at all, you have a slight malaise and if you have arrived it could be to anywhere.

Was *that* the moment of arrival – falling asleep? Certainly, it cannot be faulted for insufficient 'negative capability' (to borrow Keats's phrase). But in other respects it does not impress: arrival cannot (surely) consist of losing sight of the place you have arrived at, and forgetting who you are and what you arrived for. Around here the suspicion starts to grow that the difficulty of arrival is not just a matter of accidental frustrations and jobs to be got out of the way first, before we can arrive: it is beginning to look structural, systematic.

Other candidate moments seem even less promising. For example: the first heavy session of the local beer followed by the first Real Ale Cornish hangover; writing postcards home announcing that you have arrived; the first-morning visit to the 'souvenir' shop; a mid-holiday walk on the coastal path accompanied by a hostile minority report from the children temporarily exiled from their pleasures; a last-day trip to the fudge shop to buy presents for everyone.

Nevertheless, we keep on trying to arrive – right up to when we have to shake the sand out of our towels for the last time, fold up the windbreak, pack up our belly boards and our wet suits, draw stumps, return to the cottage, clean it up (an activity dominated by the lamentations of the vacuum symbolically bellowing emptiness, with a sound even more meaningless than that of the sea) for the next arrivees or would-be-arrivees, load the car, and drive home.

Unbelievably we are on our way back, engaged in a sad withdrawal in which the landmarks of our outward journey are served up in reverse order. We know that it has been a wonderful fortnight

and our hearts and heads and cameras are full of memories and yet we know also that we never quite arrived, were never quite there. This was a special time and yet it seems, as we fill up our north-facing car with petrol at Exeter Services and spend the last of our holiday money, that we let it go, not properly used, incompletely experienced.

We recall how at the beginning of the fortnight, time seemed almost to stand still. How far away from home we seemed by the end of Day One and how much we had crammed into it! And how, after the first few days, the clock picked up speed, as if inflation was at work. We had suddenly reached the midpoint and resignation towards, or anticipation of, the ending entered our thoughts. As if colluding with the inevitable, we began to think about things that would happen or we would do when we got home. The theme of arrival began to give way to that of departure. Half way through the second week, we were surprised to discover that we still had several whole days, indeed the equivalent of a long weekend, left; but, sensing that it was now too late, we squandered those days and gave up on the idea of arriving.

At any rate, the holiday is over for this year and we can only look forward to next year's attempt at arrival. In the grip of the sense of loss – sharper each year as we feel the passage of our children's childhood – that assails us on our return, it seems as if, once again, we had been careless of the hours given to us. How did the days slip away? What happened to the ten hours on the beach that sunny day? Time, even on the beach, had refused to clot into apprehensible duration; instead, it simply passed through us. We let it go just as much when we were happy as when we were cross, just as much when we were idling on the beach – when we should have been basking in pure duration – as when we busied ourself with some formal activity because the rain dictated flight; when we were doing

characteristic, archetypal holiday things such as building a sand-castle as when we engaged in the non-holiday activities that the combination of wet weather and children gets you into – such as visiting Tunnels Through Time or sitting in a dark, seasonless cinema. Yes, even beach-time, which has the virtue of corresponding to expectation and not being caught up with gross time-consuming travel, was dissipated in journeys: going for an ice cream, hiring a deck chair, looking for a newspaper, re-reading a paragraph of an article that had been read with so many interruptions that getting to the end of it seemed like a pilgrimage. Whatever we did, wherever we were, we seemed to drift from plans, endlessly re-planning in response to expected and unexpected outcomes. Journey led to journey, being-here seemed to dissipate to an equilibrium of elsewheres, and time eluded us.

The problem of non-arrival is not only universally true of, but also insoluble within, ordinary experience. The best – indeed the only – way to cope with an insoluble problem is not to be aware of it. To become like the child who on arrival in Cornwall, after an eight-hour, 350-mile journey, gets absorbed in the transit of a snail across the cottage lawn or counts and re-counts his holiday money or the stones on the path, or becomes fascinated by a hole in the cottage carpet or by the motif on the sugar packet, and so loses himself in that 'nowhere without no' Rilke spoke of in the *Duino Elegies*, unconcerned whether the things he is lost in correspond to or realise any larger idea dictated by expectation and memory.

Such engulfment in the particular, down amongst the qualia, like a dunnock among the hedgerows, is, however charming, difficult to envy without reservation. Beyond quite a young age, we become attached to larger mental structures, to the *a priori* and *a posteriori* essences that we conjure in our dreams and memories. We are unlikely to welcome the suggestion that the point of arrival

might be to forget what you arrived for. Leaving aside the fact that a Cornish snail is no different from the ones available in the back garden at home, it has to be questioned whether you can fully achieve holidaymaking by falling between the meshes of all ideas associated with holidays and so losing sight of the holiday. This approach may, of course, be acceptable if, having known nothing else, you enjoy the unformatted life of a child and its boundless, even if not infinite, days. Otherwise you cannot but mourn the vision lost in engulfment, just as you mourn lost Cornwall even as the sea, its essence, closes over you, and the sound of the beach and the sight of the cliffs is lost in water that could be any water.

The child's 'solution' is therefore not available to the adult. Some avoid the difficulty altogether by refusing to take holidays seriously. Others use holidays 'to catch up' – to sort out the garden, to read all the back issues of professional journals, to catalogue the butterfly collection. For those brave enough to take genuine holidays, some form of escape from the sense of incompleted arrival is necessary. I shall discuss two such escapes – or attempted escapes – chosen because they seem to me to cast a particularly bright light on the difficulty at the heart of the difficulty of arrival.

The first is that adopted by Camcorder Man (henceforth CM – it usually *is* a man who holds the camcorder for all sorts of reasons, the most obvious being that the woman is holding the baby or the fort), who devotes most of his holiday to recording what he cannot experience, in the deluded belief that when he plays back his video tape the experience will happen. CM turns over experience to the capturing of images of experience and to the creation of 'memories': he is concerned less with experience than with future transmission of experience. CM is thereby relieved of the requirement to get lost in the view. His immediate task is to identify the most favourable angle from which to shoot. Like his predecessor, the still photo-

grapher, when he looks, he looks through his hands framing the shot. He looks not in order to see but to decide whether or not to record what he is seeing. The relevant consciousness, the experience, can come later.

But there lies the problem. For the 'later' in which the fresh-frozen experiences are to be consumed may never come. When will the filmed memories be remembered? When will CM play over his videos? If the time wasn't right to look at the view when he was on holiday – with its privileged leisure and freedom – when will it be right to look at the recording of it? Is it not possible that such a time will never come and all those hours of film will remain as unlooked at as the view they record? Once his holiday is over, CM will always be too tired, or interrupted, or preoccupied. CM's solution doesn't work because he is not solving the difficulty of arrival, only postponing addressing it, and to an even less propitious time when he is in the midst of other things. If you can't experience the holiday experiences on holiday, you can't experience them at all.

Even if CM does find time to defrost his fresh-frozen experiences, won't he discover that they make the same incompatible demands on him as ordinary experience-for-its-own-sake does: to immerse himself in the particulars while not losing sight of the idea? Of course they will. So there is only one way out. And this is what has made CM and his lower-tech predecessors so notorious, indeed a species to be abhorred and one whose dinner invitations are to be rejected at whatever cost of ingenious dishonesty. For CM will try to offload on to others the responsibility for experiencing what he merely passed through. Or to get them to collaborate with him to produce the experience. He was at a very special place (Piccadilly Circus, say, or the Taj Mahal) and somehow cannot quite believe it, grasp it, experience it. Now the specialness of the moment – its recovery as an idea – is to be achieved indirectly through the aston-

ishment of friends who stayed back home. CM has proof to others that he was there, from which it follows that he really was there. The cost of recording that he was there – being busy with camera angles and hold-it smiles, and preoccupied with the treachery of technology that always threatens to let him down at the last moment and all the fiddle necessary to call back the straying tresses of the moment – is the destruction of the last shred of the experience of being there. But this, he believes, will be justified by (and hidden in) the perfection of the experience, its transformation into publicly visible reality. He was really there – and so had the experience of being there then – because his friends can now see him being there.

Alas, this does not work because the friends CM has trapped into sitting through his plotless *cinema verité* always say the wrong thing, want to talk about something else, or fall asleep and refuse later invitations to dinner with an ingenuity that takes his breath away. The postponed, transferred experience never comes and he is no more really there later on than he was at the time.

There is an alternative way out for the adult faced with an inability to experience what he has journeyed in order to experience. This is to replicate on holidays the busyness and seriousness of working life. The holiday is turned over to semi-serious tasks – I have cited catching up on the gardening or cataloguing the butterfly collection – or to non-serious tasks approached in the spirit of seriousness. Consider the father on the beach persuaded by the children to lay aside his newspaper to help build a sandcastle. In a very short time, he is organising them, directing that one to do this, urging this one not to slacken, etc. And he will continue, disgruntled at the children's infidelity to the task, long after they have tired of castle building, frantically digging ever deeper moats, adding yet more turrets, sculpting steps and boring tunnels with unyielding concentration. Two hours, three hours, pass. The result is a masterpiece.

But in an hour or so the tide will come in. The castle will deliquesce to amorphous sand and nothing will remain of his work. What more striking model of futile busyness could one hope for in human life – a process of building that long outlived the children's interest (though this will revive as the waves start to encroach on the walls), whose product does not last longer than the time it took to construct? And yet the process has served its purpose: it has relieved the builder of the burden of trying to be in an arrived state, of experiencing the experience for which he has come. The castle is a pretext for another journey – a journey towards its own completion; so never mind that the sea or the beach rake will cancel it almost as soon as it is completed.

The 'taskiness' of ordinary working life can be incorporated more systematically into holidaymaking. At least part of each day can be devoted to some scheduled activity; or the holiday itself may take the form of a trek or a tour. The difficulty of arrival is then circumvented by ensuring that journeying never stops, that the holiday is about arriving, yes, but not about being and staying arrived. On the trek – for example, walking the Pennine Way – each day has a target, a job to be done, work to be completed, for which the reward is a hot bath, a cold pint and a sound sleep. The holiday is a story of cumulative achievement. The car tour includes that element as well – miles on the clock, miles towards tea, towns ticked off, countries visited – but is even more safe from the demand to experience the people, places, things and activities that are sought out. Places are 'done': they become the accusatives of tasks rather than the objects of experience. We sit in the square at Bruges with a glass of Stella before us, not looking but planning, road maps on the table, assessing the scale of tomorrow's challenge – the journey to Cologne – our talk full of sensible ideas about how to avoid traffic jams. Like the bikers in Thom Gunn's poem, who are 'always nearer by not

keeping still', tourists arrive by perpetual travelling. At the other end of the spectrum, there is the terrible ordeal of the orienteering holiday at the end of which there is something called 'satisfaction' or something else called 'achievement'. The prize doesn't justify the hunt; but, as Pascal also pointed out, that is to miss the point, as it is the chase and not the quarry that people pursue.

Finally, the holiday may be subordinated to some entirely objective purpose: adding to one's expertise (becoming an authority on Cornish castles); picking up a sexual partner; reading the books one would never be able to tackle in the busyness of everyday life. Dedicating the holiday to some external purpose misses the point of it – or at least, the point as seen from the point of view that is being developed here. Moreover, all of these projects are themselves open-ended, arrival-less. They do not address the problem of holidays at the level at which it may be experienced: the business – or anti-business – of dismounting from labour and the Kingdom of Means and entering the Kingdom of Ends and experience. They do not, that is, address what it is that lies underneath the difficulty of arrival: the flaw in the present tense of human consciousness.

The impossibility of arrival, then, is not merely a problem associated with holidays – though holidays, lacking the alibi of useful purpose, illustrate it most dramatically – but of life itself. If we look at the three major candidate moments of arrival in life, none passes the test: birth is too obviously the beginning, rather than an end, of a journey; death is equally obviously a journey's end without arrival; and the sexual climax is not too sure where or what it is arriving at: the other person, the fulfilment of one's desires, the cancellation of one's desires, or sleep. Not for nothing is the orgasm described as 'coming'; while *having come* lies beyond the climax, beyond arrival. And this is in the absence of the physical and psychological abuses that mark so much of sexuality in the real world. The rapist's desti-

nation is even less clear: for him, 'fulfilment's desolate attic' (to use Larkin's phrase) is the starting point of flight.

The problem underlying the difficulty of arrival is universal. It can be observed in every attempt to achieve a goal – large, small or minute. Even when we are not frustrated by external and internal circumstances, by bad luck, chance, incompetence, etc. from bringing about what we intend, there is an ineradicable misfit between the specification of our wishes and any possible enactment. This arises from two sources: the field within which we enact our wishes is porous to an infinity of things that is irrelevant to them; and, secondly, we do not know how to specify our goals in anything but the most general way. No prayers are answered because there is nothing in this world that could answer to them. (This is why failure seems rock solid – for the idea, unachieved, remains intact, while success, when it comes, lacks solidity).

The difficulty, symbolised in the journey of the ball to the bat, is perhaps not so much arriving as staying arrived – about arriving at a place or an activity or an event without going past, through or beneath it – so that one feels one really has arrived. Ultimately, it is about the impossibility of *being* as opposed to *becoming* – or, as in a love affair, of being together as opposed to merely becoming together. The difficulty of arrival seems to be built into the very structure of human experience. It becomes clearly apparent, however, only where experience is sought for its own sake; where we are concerned not with means to ends, but with ends in themselves. When we dismount from function, when we leave the Kingdom of Means and enter the Kingdom of Ends, we are haunted by a sense of not being quite there; of not being able fully to experience our experiences.

*

In order to pursue the claim that the difficulty of arrival is rooted in a fundamental flaw in human consciousness, I shall enter upon what may seem like a digression, though it will bring us close to the heart of the matter. We shall arrive, that is to say, by stealth. I want to consider Kierkegaard's problem – or category – of *repetition*. The difficulty of arrival is considerably exacerbated – perhaps only fully experienced – after the first, the unforgettable, the founding, holiday. In subsequent holidays, arrival doubles up as return and experience has the role of confirming memories, of securing repetition. With successive returns, we find ourselves rather like those who go to the great art galleries not so much to see great paintings as to check out, or be in the presence of, the originals of the reproductions they know so well. Since the postcards came first, the paintings have a third-order, rather than first-order, status: existing in relation to the second-order postcards, they are effectively reproductions of the reproductions. In the case of holiday re-visits, it is postcards of the mind we are chasing, mental images that have been elaborated by reminiscence, assisted by all sorts of memorabilia such as real postcards. The postcards of the mind are even less easy-going than the anticipations based on words and images.

The pursuit of the past is further frustrated because those who are pursuing it have themselves changed. The child who was transfixed by a lugworm cast or waited impatiently for the Piskie Gift Shop to open has given way to the reader of books on World War II and to the maker of model aeroplanes. The crying infant who had continually to be placated over a six-hour journey now surfaces from a book from time to time to make a caustic comment on the fact that we are exceeding the speed limit. (Indeed, the journey seems too easy; the frictionless passage down the M5 – in a more reliable car than ten years ago – is hardly journeying at all compared with the heroic ordeals of the past, and this is another reason for

attenuation of the sense of arrival.) The changing structure of our children's consciousness has altered our own. And we ourselves have different hopes and hungers. Plans have been fulfilled or long since definitively dashed. We are coming to Cornwall from different places in our lives.

And this is one reason why it is difficult to visit the same place twice. Even moments of pure repetition do not repeat. Consider the doze on the beach. How much remains unchanged: the feel of the sun on face, the sound of the sea, the near and distant shouts of children and the cries of babies, the rhythmic thud of the unsynchronised mallets adding up to an arrhythmic chorus, the snap of towels in the wind, the transmission of footfalls through the sand. This, surely, is return: recurrence of absolutely the same sensations. It is not; for the sensations have different contexts. Different human voices wake you and you drown in a different sea. Whether it is the Cornwall of one's children's infancy or (as with Kierkegaard) the Berlin of one's student days, the way back to the past is blocked by inner obstacles. The avenues and trees may be as fugitive as the years, as Proust sighs, but their departure is hastened by the inner fugitiveness of the avenue-bibber and the tree-sipper.

So much is obvious and it is one reason people shrink from going back to a place where they have been happy. Or they choose to go back only in spirit: sifting through the inner and outer memorabilia – the hour of reminiscence, the evening with the photograph album. This, however, is unsatisfactory: the imaginary visit is fragmented and frail, vulnerable to the slightest interruption from the front door or the telephone, liable at any moment to dissolve in the ordinary tiredness of a Wednesday evening. So people do, after all, weaken and go back literally to the place where their holidays' memories point. And the delight of anticipated re-discovery is striated with a certain tension that things will not be the same. The place

may, of course, have changed physically: the beach hut may have been replaced by a multi-storey leisure complex. But empirical clash between observed and remembered fact is merely accidental and, in a sense, beside the point.

A more pertinent and poignant tension comes from a deeper conflict between the idea of the past and the reality that actually corresponds to it, so that we journey towards *ideas* of experience that no experience can realise. Ideas differ from any possible experience in two rather fundamental ways.The first is that sense experience is so much more *detailed*; it is baggy, obese with contingencies. My conception of the game of cricket on the beach did not include any of the very particular items of which it is composed – that particular shot, that seagull flying overhead, that thin man shouting to his wife. The beach hasn't suffered structural change and the headland is precisely as it was the first time we came but our memories did not include this particular sunlight, that woman in a green skirt walking that yappy dog, that kite straining on its string, this particular sensation of the little one tugging on my hand or this particular fullness in my stomach.

Compared with actuality, even the most detailed memories are sketchy, incomplete, catching only what we are now pleased to think of as the essence. The place we revisit in pursuit of re-experience of our memories is freighted with contingent details, none of them necessarily at odds with the specification, but none of them part of the memory either.

And there is another important difference: the idea is given all at once in an instant of anticipation or recall, while the experience unfolds over time. The idea has a clear *form* which the experience lacks. That is why experience is riven by a sense of insufficiency, why we feel that we are not quite experiencing it. Hence the difficulty of arrival which, we discovered, is not accidental or incidental but quite

systematic and essential. The sense that, once everything is in place and the things that blow us off course are dealt with, we shall arrive is misleading.

The essential difficulty of return, then, is due to the unsatisfactory relationship between ideas and experiences. We can't return because we cannot visit an idea or revisit an experience that has become an idea: the experience of reality has as its context more reality; whereas the idea has as its context mental images transilluminated with loss, nostalgia, longing. And so we move near to the heart of the problem – a problem reaching to the heart of us, to the heart of consciousness – which, according to Kierkegaard, is that of the 'relation of opposition between actuality and ideality, an opposition discovered through repetition'. For, although we have been talking about the impossibility of *return,* the intention has been to cast light on the impossibility of arriving in the first place. Finding it impossible to *be there again* – in the fullest sense we should like to be – is an aspect of the impossibility of *being there at all.* If we strip away accidents of external and internal change, we see our inability to return to a place for what it truly is: a manifestation of our inability fully to come to that – or any – place even for the first time. For in order really to come to a place, to enjoy the sense of having fully arrived there, whether it is a first visit or a re-visit, it is necessary to resolve what is in fact an unresolvable tension between experience and idea – either between current experience and experience that began as an idea (anticipation, preconception), as in the case of first-time arrival, or between current experience and experience that has grown into an idea (memory). Even though when we arrive for the first time we are not apparently revisiting or trying to recapture a place, our difficulty is very similar to that of achieving repetition. For we bring to our destination an idea seeking confirmation, embodiment or fulfilment, expectations based on what we know, or

know of, the place we are coming to. And so *all* our arrivals are like returns, a search for the equivalent in our senses, in what we actually experience, of our conceptions – in the case of the first visit, of our *pre*-conceptions. Every visit, therefore, even the first, is a re-visit.

The difficulty of any arrival is that of achieving a present moment in which the idea and the experience, our knowledge and the data of our senses, are one, are co-conformable, so that we know what we experience and our experience conforms to our knowledge. The failure of experience to correspond to idea, to satisfy it, is not merely a question (as it is so often presented) of the real *falling short* of the ideal. On the contrary, as I have emphasised, reality often exceeds or overflows ideality, at least in the sense of being more detailed, more complex and more richly unpredictable. It is not merely a matter of a conflict between romantic ideal and drab reality but between a purified, mind-portable version of reality and reality itself.

The impossibility of repetition confirms, if any further confirmation were necessary, that the difficulty of arrival is not a problem uniquely to do with holidays. Nor is it merely accidental, to be solved by a better organised, better-funded package. It is about the ends and aims of life, about fulfilment beyond the tasks of survival, about consciousness beyond work and responsibility and unchosen distraction. If it is particularly apparent on holidays, this is because, for a uniquely sustained period of time, we are concerned solely with having experience for experience's sake, not for the sake of some useful purpose: we travel to a place in order to experience rather than to be busy and to achieve; we look for the sake of seeing rather than in order to obtain information. Under such privileged circumstances, the difficulty of *being fully there* – which is what the systematic elusiveness of arrival is all about – the difficulty of apprehending the present moment, becomes uniquely apparent. It is then that the mind feels like a fist that has lost sensation but has lost none of its power: though it can grip, it feels as if it has lost its grip.

In our daily lives, then, we are 'never quite there'. In the present, we elude ourselves and the world eludes the grasp of a fully self-possessed experience. It's not just that you cannot step into the same river twice, our being is becoming: the self subsists in moving away from itself. Man, according to Kierkegaard (in *Either/Or*, 1843), 'does not have a stable existence at all, but he hurries in a perpetual vanishing'. Without the category of repetition, he writes 'all life dissolves into an empty, meaningless noise' (*Repetition*, 1843). Repetition is both the 'interest' of metaphysics and 'also the interest upon which metaphysics comes to grief' – a theme that has preoccupied existentialist philosophers. Most notably and most eloquently among them, Sartre dwelt brilliantly (especially in *Being and Nothingness* and in *Nausea*) on the non-coincidence of consciousness with itself, on the systematic elusiveness of the I, and on the related non-coincidence of the (universal) word with the (particular, actual) thing. And this feeling that we somehow elude ourselves is reflected too in this passage from the *Duino Elegies*:

> For we, when we feel, evaporate; oh, we breathe ourselves out and away; from ember to ember yielding a fainter scent. *Rainer Maria Rilke, Duino Elegies, Second Elegy, translated by J. B. McLeish (London, Hogarth Press, 1967)*

The Significance of the Arts

> The creation of art is the only metaphysical
> activity to which life still obliges us. *Nietzsche*

We are often unhappy animals who have woken to a greater or lesser extent out of our organic state. Half-awakened, we are constantly engaged in making explicit sense of the world and of our fellow humans. This sense remains tantalisingly incomplete and stubbornly local. We go to our deaths never having been fully there, except perhaps in our final agonal moments when we are reclaimed by our bodies, and never having quite closed the gap between what we are and what we know, our ideas and our experiences.

For most people throughout most of history, this has scarcely been an issue. The hungry, the oppressed, the frightened, the aching, the itchy and the bereaved, find the local, unchosen, meanings that they have to contend with quite sufficient. They are immersed in the Kingdom of Means. Affluence, born of technological advance, however, has resulted in increasing numbers of people for whom the Economic Problem has been solved, who are in good

health, who are not oppressed, and who are selfish enough not to be overly concerned with the needs of the needy. They have sufficient leisure to think beyond means to Ultimate Ends. For them, the incompleteness of the sense of the world may become a problem.

The commonest response is increasingly frenzied activity, usually involving consumption of goods, substances, entertainment, and of each other. Motor cars, Bargain Breaks, Stella Artois, orgasms, are thrown into the hole in sense. These, while excellent in themselves, do not palliate the fundamental hunger. What's more, such inflamed consumerism may have serious consequences that will ensure the return of the Economic Problem with a vengeance. The rising curve of consumption threatens the future habitability of the planet; and an increasingly consumerist attitude of individuals towards each other imperils the future of civil society. Fun-obsessed individuals, what is more, increasingly approximate to the condition of 'Humean beings' in the grip of 'and then . . . and then . . .' The attenuation of presence by e-sense – as the inability to sit still is exacerbated by the inability to be here without endlessly reaching out towards, and receiving input from, an electronic elsewhere – is a striking symptom of what is happening. In short, there are no easy, or Easy Jet, solutions to the question of what it is to be a human being and live life abundantly when material needs have been met. We need to look elsewhere.

*

There is an incurable wound in the present tense – the only tense that human consciousness really has. The difficulty of arrival is the difficulty of *being*. The requirement to arrive, to be completed, is close to the religious demand for 'mindfulness' and the mystic's search for an absolute self-remembering, when the material, parti-

cular self is transparent with knowledge, and knowledge is solid with material presence.

The thesis I shall advance here – tentatively and with a good deal of qualification and even unease – is that resolving this opposition is a, possibly *the*, function of art. That at least in the secular West, at the present time, it falls to art to address the wound in the present tense, and to dress it and perhaps for a while to heal it. Art is about achieving arrival and arresting, however momentarily, becoming to being. A fundamental impulse of the artist (and the delight afforded by art) is rooted in the need to satisfy, if only intermittently, the hunger to *be* entirely where one *is*, so that subjective reality and objective situation coincide, and experiences are fully experienced. Art helps us to be more solidly *there* than even anticipation imagined we would be; more *in* the present moment even than we might remember ourselves as being when, in an old age pruned by loss, we wake on a dark cold 4 a.m. and remember the sunny days by the sea with the children who have now grown up and left us.

It would be as well to say at once that I recognise the stupidity of subordinating something as complex and profound and various as art to a single task, howsoever 'metaphysical' that task may be. It would be both arrogant and vulnerable to suggest that I have identified the sole purpose of art or to state categorically that even in a secular society only art serves this purpose. A more modest, and appropriate, assessment of my thesis is that it is an attempt to answer the question, what kind of function art might have, given that it serves no practical and moral purpose and that the notions of inner enrichment and of the educational value of art are highly suspect. My thesis, in short, is an attempt to indicate the kind of things that art might do on the far side of use and why use is irrelevant to, or only incidental to, art.

How does art address the wound in the present tense? How does it reconcile the sensory and intellectual dimensions of consciousness, the particular experience of what is there with the general ideal of what might be there, our abstract notions with our concrete sensations? To understand how art unites these adversaries, it is necessary to invoke the general concept of *form*.

To describe this concept as 'complex' would be a spectacular understatement. For, like art itself, 'form' is an intricate nexus of notions. Moreover, it has evolved through history but, for a variety of reasons, among them the unsurpassed genius of those who first thought about form, it has retained its earliest meanings alongside more recent ones. 'Form' for this reason would not unfairly be described as, semantically, a coral reef. The complexity of the term is compounded by its being used as a battle cry or, conversely, a jibe in aesthetic and other disputes. It permeates not only aesthetic but also metaphysical, psychological, scientific, sociological, mathematical and other discourses. The term, in short, has a seemingly limitless plasticity: a semantic polyp, perhaps, rather than a coral reef.

It is important, therefore, to keep things simple and focus on the core idea of form as *the shape of a thing*. In the case of works of art which are composite and multiple, 'shape' refers less to the outline than to the 'inner shape' or *arrangement of parts*. The arrangement is an orderly (or calculatedly disorderly) one: form in art is largely about (even in rebellion against) 'due shape, proper figure'; the form conforms to – or, more recently, refers to, plays with, undermines – a model, type or conventional pattern.

This doesn't say very much about how artistic form differs from forms encountered outside of art or, within art, about the difference between the great and the mediocre. It is easy to speak of idealised, geometrical forms in the visual arts; of the surface forms of literature – rhyme, rhythm, narrative line, etc.; of the tonic and

the dominant in music. But this will not demarcate good artistic forms from less good ones and might suggest that art could be created according to a recipe. Moreover, any specification of form that was common to all arts at all times would be very abstract indeed: the highest common factor would be a very low one. Besides, there are aspects of form in individual works of art that seem to go beyond all specifiable features; that are, in other words, uniquely realised in, uniquely expressed in, the work itself. There is a sense in which every great work of art is *sui generis*.

This should signal the limitations of the theory that follows, though I will try to address some of them in due course. For the purpose of present discussion, however, one feature seems to be crucial. We may think of form in art as that by virtue of which things otherwise experienced or considered separately are brought together as one: that *unity in variety* which conveys the sense of sameness in difference. We may look beneath this to a sense of *stillness underneath change*, and to the Aristotelian idea of form as the *moving unmoved*.

Let us then run with the key notion of form as the agent by which unity is achieved across variety, a unifying order, a principle of coherence. If we think of the difficulty of arrival as the failure to obtain experiences that correspond to ideas that are at once larger and lighter than them, then art would address this problem by providing such experiences. By bringing together things that are separate in space and/or time, without sacrificing their separateness, the work of art embodies the large notions that otherwise elude us and makes them experienceable; or, to put it another way, affords us experiences that are transparent with ideas. How is this unity-in-variety achieved?

Consider symmetry. This unites all the things that lie on either side of a plane of cleavage, howsoever heterogeneous they may be among themselves, through a one-to-one relationship with the

elements on the other side: even if the elements on each side do not belong with one another, their contribution to the matching halves unites them. Or think of a set of musical variations: there is change or variation but the variants are united by the invariant that is necessary for them to count as variations. Or metaphor – defined by Aristotle in the *Poetics* as 'the intuitive perception of similarity in dissimilarity' – which unites two partially similar objects and so overcomes that within them which is dissimilar: it is therefore a way of poetically discovering in or imposing upon the variety of the world a greater oneness. (A good metaphor is both an image and an idea; as Arnold said in 'The Study of Poetry', it is in poetry that 'thought and art are one'.) Or certain recurrent or persisting features – rhyming sounds and rhythm in poetry and music, or motifs in literature, the visual arts and music – which assert that things have not changed, despite the changes that have taken place. Or the cyclical form of a piece of music that modulates from the tonic to the dominant key and then back to the tonic key: there is no 'net' progress; rather, stasis in change.

The common function or effect of these formal features that unify across variety is to integrate experiences that would otherwise be separate. Incongruous and disparate things may be brought together: outrageous couplings, dissonant discourses, disjunct objects; all the nears and fars of the world; booty from the four corners of the empire of experience. This permits an experience arising out of the work that expands into and fills the lineaments of something larger than experience; something, in short, like the ideas that we hope to experience when we seek out experience for its own sake. A work of art is a concretely realised idea – an idea as large as those that haunt our consciousness through anticipation and memory; larger than those that are realised in ordinary experience and which, as we noted, often undermine or devalue ordinary experi-

ence. The fundamental tendency of art is to extend the 'mindful' through form, through an arrangement of parts, which enables many to be presented through the one, unity to be found in, or imposed upon, variety.

The formal structure integrates over time in music, over space in the visual arts (though we seem to unpack space from music and we experience paintings and sculptures in time), and over multidimensional hyperspace in referential, non-iconic forms such as literature. In non-referential arts such as music and abstract painting, it is the actual sensory experiences – sounds, colours – that are integrated, while in the case of referential arts such as literature and representational painting the elements that are integrated are not there *in propria persona* but by proxy, as referents. The distinction is not sharp; poetry, for example, may work at the level of word-sounds (actual sensory experiences) as well as at the level of word-meaning, and integration takes place at both levels.

The means by which integration through form is achieved vary enormously across the arts: in music, rhythm and interval, melody and harmony, constituted by the relationship between notes, between chords, between variations, between movements; in visual art, the pattern of shape and colour, symmetry and contrast, repetition and variation; in verse, metre and rhyme and the ordering of referents; in fiction, the ordering of events, the structure of plot and theme, recurrence and repetition and contrast. The common feature is that temporally and/or spatially and/or conceptually disparate things are gathered into a unity: the many becomes one, without losing its character of multiplicity; change becomes stasis; movement is unmoving.

How does this solve, or at least palliate, the difficulty of arrival? It is perhaps easiest to understanding this in the most obviously formal of all the arts – music, an only weakly referential art

whose ordering of parts is not significantly determined by an external (extra-musical) reality. Think of the relationship between idea – or form – and sensation in the experience of a melody. Each note is fully present as an actual physical event and yet, because the music conforms to a form that shapes expectation and assists recall – through conformity to the rules of harmony, of contrast and symmetry, of progression and repetition – the note is manifestly and explicitly part of a larger whole. There is no conflict therefore between the form or idea of the music and its actual instants. Our moments of listening are imbued with a sense of what is to come and what has passed. The form to which the music conforms – that ties what has gone and what is to come with each other and with what is present – shines through its individual moments.

The continuous genesis and satisfaction of expectancy in the listener is based in part on previous experience of instances of the form to which the work belongs and in part on previous experience of the piece itself. In the case of 'difficult' music, where forms may emerge over longer stretches of sound and the standard expectations will be defeated in order to be satisfied in different ways, expectancy may have to be 'trained' by previous exposure – to the style or genre of the music and, probably, to the piece itself. Repeated listening may be necessary before, say, the succession of notes in a piano sonata persuades us of its absolute rightness and of the validity and reality of the sound world it seems to catch up or show forth. It takes time, that is, for us to see, to experience, the pattern in the music; repeated listening is necessary for this to acquire an *a posterior* inevitability. (Repetition in art, as opposed to life, can be based on the certainty that the same elements will be served up in the same temporal or spatial order – though the recipient is free to choose otherwise.) Once the pattern has been recognised, all of it exists at once, even though it is gradually being realised in time, so that from

the first note we are arrived and stay arrived. There is both movement and stasis; in quasi-Aristotelean terms, the unfolding sound realises form as the 'moving unmoved' (or 'the unmoving moved'). The difficulty of arrival, for a consciousness that in ordinary life seems to move past or through its goals even as it reaches them – so that it does not somehow realise them even when it achieves them – is thus overcome.

Of course, the music has its journeys – it manifestly is a journey from a beginning to an end – and in great music we feel as if we have travelled great distances to and through a remote *paysage* of sound. But the journeying is never merely a piece of *en route*: the unfolding of the form fills and fulfils the sensation of the present moment with the past and the future, rather than undermining it with the past and the future. Each moment requires *every* other moment, for the reason that will be clear from Yehudi Menuhin's description:

> Music creates order out of chaos; for rhythm imposes unanimity upon the diversity; melody imposes continuity upon the disjointed; and harmony imposes compatibility on the incongruous.

The leitmotif, recurring throughout the music like an involuntary memory, ties together the beginning, the middle and the end, making it all one. The retrospective light it casts on all that has gone before creates the feeling that we have been arriving all the time and that, indeed, we are arrived.

When the music is '. . . heard so deeply/ That it is not heard at all, but you are the music/ While the music lasts . . .' (T. S. Eliot, *Four Quartets: The Dry Salvages*, Verse V) we are completed in an experience that is truly experienced. We are here and at the same

time *know* that we are here, and the knowing does not undermine the experiencing by creating and serving a hunger beyond experience that attenuates, distracts from, even obliterates it. So although music, too, has its journeys, its continuous aways and towardses, these are not separate from arrival, or parasitic upon some alibi of arrival: a fever of fulfilment is maintained even as fulfilment is laboured towards. We listen to music not in order to get to the end of it; or we recognise that to do so – say, to sit through a symphony, to listen through or past it merely in order to find out what happens in the end, or who wrote it – is a perversion of the musical experience. We want to see the form build up not merely in order to satisfy our curiosity as to what it is going to be, so that the present moment is something to be got through, but to undergo the experience of the form building up. The building-up of form and the physical experience of each stage do not undermine one another. The destination of the music does not erode the present experience: journeying is standing arrival; form and content are one, the latter transilluminated by and evident in the other; becoming, conforming to its own form, is arrested to being. Meaning is at once completed and in process; unfolding and unfolded.

Music is a perfected journeying, which is continuous arrival. That is why, although it is so clearly intrinsically temporalised, it is a liberation from time: it has the hurry of time, but in it the away and the towards of time are united. And that is why, also, there are moments when, listening to it, we have the sense of enjoying our own consciousness in italics: like a hurrying river dilating into a lagoon, our becoming has dilated into being.

The extent to which the identification, enjoyment and appreciation of the formal properties of art is innate, a universal of human consciousness, as opposed to being conventional, taught and culture-relative, is disputed. *Gestalt* psychologists attempted,

in postulating 'Laws of Good Form', to relate aesthetic principles to the fundamental properties of the human mind and, indeed, to identify an aesthetic element at the heart of perception itself. The expectancy that enables us to complete an object that is only partly visible or to anticipate the next step in a series of sounds is informed by a sense of 'Good Form' and 'Good Continuation'.

Perhaps human consciousness is instinctively aestheticising at this very basic level, so that it is a sense of form that separates ordinary, meaning-filled experience from a 'blooming, buzzing confusion' of sensation, and ordinary reflection and thought from a delirium of memories and ideas. Certainly it seems that a form-finding (or form-imposing) and unifying tendency in consciousness is necessary to transform a series of sensations drawn from different senses into the perception of an object, and to bring together the successive deliverances of different senses into an experience of a world: the production and perception of form lies at the heart of the intelligibility of the sensible world. We recognise objects through certain general or formal features; and, by the same means, larger spatial and temporal arrangements are identified, or extracted, from the flux. To see, as Goethe said, is to theorise. Without such a faculty or propensity in ordinary consciousness, it is difficult to see how art could be either produced or enjoyed.

Acknowledgement of the aesthetic element in ordinary consciousness generates problems, however. If we accept the Gestalt psychologists' idea that a sense of Good Form lies at the root of the expectancy, shaped by the past, that explicitly links the present with the future, and is essential to our completion of inescapably partial experience into a complete world, then we might be at a loss to say what is special about the aesthetic sense we associate with the production and reception of art. Why do we need art and how is art demarcated from other aspects of human life? We could put this

question another way. If ordinary sense experience is rich in forms, if every moment of perception presupposes the construction and/or identification of general and universal forms, if we recognise the contents of the world as instances of general types, in what way is experience deficient?

The unsatisfactoriness of daily experience is not due to a deficiency of forms. On the contrary, the moments are abuzz with an *excess* of forms. Think of ordinary conversation, which is composed of forms: of individual words that realise formal structures at both the level of sound and of meaning; of sentences, which are highly ordered and obey complex structural rules; and of larger orderings beyond the word and the sentence. Even the simplest anecdote has a beginning, a middle and an end. Why, then, do we need specifically artistic forms? Forms encountered in or extracted from or synthesised by ordinary daily experience are transient, or nascent, and on a small scale. They compete with one another and so cancel each other out, like a multiplicity of signals adding up to noise, or several perfect waves summating to mere turbulence. The seeming formlessness of successive moments of ordinary experience is of course comparative: the fugitive forms with which the present moment seethes are smaller than the great structures, the unities and the wholes, that are figured in memory-and-knowledge-charged anticipation and which we are driven to seek out and realise in experience.

We need art, then, because ordinary consciousness falls short of fully uniting particular physical experiences with these larger forms derived from knowledge. That is why experiences seem incompletely experienced. Yes, we have the micro-arrivals of experience – after all, perceived objects are here before us, and we and they are here – but these do not match up to the greater and more sustained arrivals demanded by memory and anticipation. Just as

without this fundamental form-creating faculty of consciousness, art could neither be made nor appreciated, so it would not be necessary, either: for we would not suffer that sense of the incompleteness of sense, of the failure to realise the idea of experience in experience itself, to which, I am arguing, art answers. The very formal sense that makes ordinary experience possible contains the seeds of the formal hunger that makes ordinary experience insufficient. Art is concerned with larger, more explicit and more stable forms than are experienced or experienceable in everyday life.

These forms may be constructed out of the material of everyday life – as in referential or representative art (literature, painting, etc.) – so that much that would otherwise be dispersed is brought together and the recipients are afforded a synoptic view denied them in daily life. Or the forms may be autonomous – as in abstract painting and music. Or, finally, be somewhere between the two as, say, in iconic painting or more recent art where figurative elements are used non-figuratively as motifs. Even in the case of representational and referential art, where 'the arrangement of parts' is determined at least to some degree by the organisational properties of the represented object or the referent, there are autonomous formal features. In literature, these include rhythm, rhyme, larger metrical patterns, the unfolding of the plot, the interaction of plots and subplots in the convergence and divergence of events. The selection of items in narration (which is not, after all, replication) permits the exploitation of motifs in the establishment of structure, of conscious dissonances between situations and voices, the manipulation of thematic contrasts and harmonies. For this reason, it is recognised that referential and representational art is, as has often been pointed out, not so much a reflection of nature as the creation of a second nature – though this second nature may, of course, be true of and true to the first.

Think of all the preparation – the planning, the booking, the packing, the travelling, the unpacking, further travelling and loading and unloading – necessary to reach the moment when an ice cream is dropped in the sand or someone chases, slightly cross, after a ball that has been hit miles too far while someone else, slightly bored in the outfield, toys with a lugworm cast. Or the frantic hours of digging and shaping and sending out for more buckets and prodigal spending on spades and directing and shouting that go into making a castle whose fate is to be dissolved by the sea within an hour of completion. Such a minute statue placed on such a huge plinth! What we get from art is not simply experiences – or proxy experiences in the case of referential and representational art. These are available *ad libitum*. Nor is it simply ideas rooted in experience, ideas embedded either in sensory experience (as in music) or particular referents (as in fiction).

The difference between art and ordinary experience may be summarised in this way: experience is integrated into a world; art integrates more widely, at a higher level, across that world; and it makes 'ordinary' integration – implicit in the partially achieved wholeness of the perceived world or of the perceived sequence of pattern – more explicit. This integration is achieved through the unity-in-variety of form. When we submit to a work of art and dissolve into its form, we are united within ourselves. Idea and experience are as one and we may, if only temporarily, arrive.

*

The first, and perhaps most telling, objection to this theory is that we do not require any art in order to be fully there. Our inability to experience our experiences is scarcely an issue when we are being tortured, even if the enemy is only a humble toothache. In order

to be 'entirely there', all we need is to drop a brick on our foot. Moreover, those who are hungry or suffering the anguish of bereavement or the various sorts of terror the world has to offer – most people for a good deal of their time – do not need anything additional to make their present moments sufficiently real. And even when we are not in actual discomfort, we are usually caught up in the present, oppressed by the press of events, possessed by the demands the world makes upon us in return for the demands we make upon the world. Behind this objection are venerable traditions: pinching oneself to make a situation real, self-flagellation to heighten self-presence, undergoing ordeals in order to exist more authentically.

Suffering does not seem to me to be a particularly attractive alternative to art. It catches up many opaque elements. Much pain, for example, is senseless sensation, unilluminated by knowledge – as well as being intrinsically undesirable. It is not synoptic, boils down to its own moments; it is anti-knowledge, anti-idea, anti-meaning. Even when chosen, it nails one to the particular, is a matter of successive windowless moments, unilluminated by past or future. (And the choosing of pain is often a brief moment compared with suffering the consequences of the choice. The large literature on sexual pain seems to overlook how the instant of sado-masochistic, ecstatic sexual pain is outweighed by the hours, beginning with the wait in the A&E Department, of meaning-impoverished discomfort.) More importantly, most suffering is unchosen – and our concern here is with the ultimate ends and aims of human life and consciousness, and therefore with what one does when one *has* choice. Pain may 'cure' the sense of the insufficiency of presence but only at the cost of downgrading consciousness; it is no more a solution to the difficulty of arrival than are coma or death.

To be in pain or fear is to be enslaved. Art is the opposite of enslavement, even self-enslavement. In one of his most famous

essays, Sartre defined art as 'the world appropriated by a freedom'. This definition is vulnerable, not least to the argument, with which Sartre himself is most famously associated, that *every* moment of consciousness is the possession of the world by a freedom. Nevertheless, the definition captures something essential about art: that it is the means by which we may possess the world that usually possesses us. Art is concerned with the completion of our freedom in those times (admittedly rare and privileged in our own lives and in the collective life of mankind) when we are not involuntarily engulfed by the present moment. It is under such circumstances, precisely when we are not fastened to unsolicited, unpleasant experiences, that experience may become elusive, unreal, and the difficulty of arrival an issue. When we are not apprehended by pain, fear or anguish, or even mere busyness, the present moment, the self, becomes inapprehensible. Art is about making delight as solid as pain; about being at least as totally *there* in positive moments, when one is joyful and open to others, as in negative moments of pain, solitude and loss.

The extent to which the form of a work of art – or the form (of a world) revealed through or in a work of art – is appreciated will vary from individual to individual. Some (very few) can grasp and enjoy the formal relations between the elements of an entire symphony; more will be able to experience them over the duration of a single movement; and some over only brief passages of melody. An individual may be more alive to the formal structures in one art than another. More people are, for example, able to appreciate or experience the form of a chapter in a novel than the form of a symphonic movement. (This is in part because a novel has a *referential* form, for example, the 'story-line', as well as an internal form, such as a pattern of symbols or recurrent *leitmotiven*.)

There may be variations even within a given individual in sensitivity to a particular art-form, even to a single work. Our experience of listening to a piece of music for the first time is quite different from that of subsequent listening, and each of these may be different from one another. Likewise, re-reading is a very different experience from reading (with or without the intervention of literary critics). The first struggle through a complex poem is nothing like a hundredth re-reading, which is often like a return to a familiar corner of one's own mind. Re-reading a novel has only a family resemblance to reading it in ignorance of how it ends. When Gide said, 'one writes to be re-read', he meant that he wrote for an audience of re-readers sufficiently liberated from vulgar curiosity as to how things are going to turn out to be able to appreciate the formal power of the work. However, we all of us have some sense of artistic form: there must be few people who are insensitive to the storyness of a story or who do not feel the formal beauty of a melody – whether it is the recurrence of a Wagnerian motif or the playing of a familiar pop tune.

The question of length and the scale of forms is a difficult and important one and it touches, as most aesthetic questions do, upon both the psychology of response and the issue of convention. The problem does not arise seriously with music (or most music, anyway), with short poetry or, of course, painting and sculpture. Long poems and novels present difficulties. Valéry (after Poe) famously suggested that a poem could not be more than a hundred lines long; anything longer was really a series of shorter poems with linking material. This would not satisfy the admirer of *Paradise Lost* or of *The Faerie Queen*. And it is easy to think of the latter, in particular, as a vast country of *topoi* rather than a single, massive embodied form.

The problem would seem to be even more acute in the case of novels – especially large ones. Fiction typically has the unifying element of the plot, or of the interaction between plots. First time round, the plot is merely story – which we may think of as a withheld fact, or a group of withheld facts, combined with the means of creating an appetite for them. Second time round, the plot may be thought of in more purely formal terms: the re-reading is not a journey towards a revelation but a realisation of a trajectory whose goal is already known – rather as in a familiar piece of music. (As noted already, in a work of art, but not in life, there is genuine repetition – not only of the events but also of their temporal order.) And there are additional forces for coherence in the novel: recurrent themes (for example that of involuntary memory in *À la Recherche du Temps Perdu*); *leitmotiven* (cultivated with especial consciousness in Thomas Mann's Wagnerian novels, but evident throughout literary fiction – think of all the allotropes of fog that permeate *Bleak House*, of the black and white butterflies in *Madame Bovary*); symmetries (as in the hour-glass cross-over in *The Ambassadors*); and so on. All of these permit a great novel to become a living whole and its huge tracts mind-portable so that they can be realised as a form. E. M. Forster's claim about the 'massive musical forms, the great chords' sounding in *War and Peace* emphasises this hidden unity, this formal wholeness beneath the 'loose, baggy' (to use Henry James's adjectives) surface of fiction.

*

To ascribe a single overriding function to art may seem to imply that art is a single thing. Any discussion of art in general must yoke together objects, activities and experiences that are fundamentally and irreducibly different. Painting, sculpture, music, poetry, fiction:

it would be difficult to think of a more heterogeneous collection of activities. Any talk about 'art' that is not mindful of the great differences between the individual arts is in danger of being banal and unfocused. My aim, however, is not to deduce aesthetic principles of *specific* arts. There is unlikely to be a metaphysic of rhyme or a demonstrable relationship between the structure of human consciousness and the sonata form. And metaphysics will certainly not explain how a particular work has – or fails to have – particular effect, why one work is good and another is not, or help to differentiate between the reasons why something is good versus the reasons why it is enjoyed. I am concerned only with the needs to which art is a response, the origin of those needs in the fundamental character of human consciousness, and what it is about art that enables it to meet them. In short, with what the arts, across their enormous differences, have in common: the property of instantiating a formal structure while being rooted in particular experience; the capacity to satisfy idea-hunger without deserting particular experience.

The reason why this property is easiest to discuss in relation to music is that it is a non-referential art and its forms are, therefore, more completely embedded in particular *physical* experiences. The music *is* what it sounds; it can never (to allude to the old joke about *The Ring Cycle*) be 'better than it sounds', in the sense of entirely rising above the sounds it is composed of. (It can never fail to deliver what it – as opposed to the programme notes – promises: it *is* what it promises.) Form and content are mutually embedded, and inseparable. By contrast, other types of artwork may reach out to an 'external' referent. For example, a representational sculpture refers to an individual, or type of individual: it is a sculpture *of*; it has a highly focused, externally targeted 'intentionality'. Although it is naive to think of Michelangelo's *David* as being about a particular absent individual called David, it certainly is about an idealised or

archetypal young man. This specific 'aboutness' is even more evident in the case of representational painting. The aboutness of literature is much more wide-ranging: compared with painting, the ratio of material substance to referent is tiny.

Music's lack, or relative lack, of external reference has suggested to some, most famously Schopenhauer and Pater, that it is the purest of the arts – almost Valéry's 'art purged of idols' – that, uniquely, it realises the powers and purposes of art. Because they are not shaped or regulated by referents (in Schopenhauer, by the world-as-idea), the forms of music are not borrowed from the external world: nothing naturally occurs in sonata form. Its language is autonomous and has no extra-musical uses – something that the French Symbolist poets in particular envied it for. The fusion between form and content is all the more complete because the latter exists only in order that the form should be realised. Music is not burdened with a duty of fidelity to an external world: it lacks an extra-musical agenda. It has therefore been seen as the paradigm of the arts and its condition that towards which all other arts should 'aspire'.

Certainly, the union of form and content, which is supremely evident in music, must be possessed in some degree by all arts if they are to serve the purpose I have identified. This is why the choice of music to illustrate the notion of form as the 'moving unmoved' and its relation to the function of art is a natural one. But this brings the danger of exaggerating the extent to which arts are non-referential, establishing an autonomous realm rather than expressing external, non-artistic reality. Non-referentiality can be seen as a deficiency as well as a virtue and it could be equally argued that music is the least typical as well as the most typical of the arts. Its lack of clear connection with extra-musical reality, or of precise reference to elements in the rest of our lives, certainly makes it utterly different from what has, arguably, been the dominant art form: literature.

This much I would concede: the relative non-referentiality of music enables us to see the 'artiness' of art most clearly in it. But it does not follow from this that non-referentiality is an essential feature of art, its *sine qua non*, so that referential art (such as representational painting or literature) is inferior as art and all art ought to aspire to the condition of non- or self-referentiality. The confusion between non-referentiality, musicality and artistic superiority has given rise to harmless idiocies – such as the belief that abstract art is closer to music (that, indeed, it is a kind of colour music) and because of this counts as more 'advanced' than representational painting. But this misunderstanding has had more serious adverse effects on thinking about art.

Consider, for example, the influential school of poetics originating from Roman Jakobson. Its proponents maintain that the essence of literary language is the foregrounding of the material tokens of language – the actual sounds – at the expense of their referents. In literary usage, as opposed to other uses of language, words draw attention to themselves. Literary discourse is characterised by opacity and self-referentiality. This, it is claimed, is particularly evident in poetry whose 'poeticalness' is manifested in such devices as rhythm, onomatopoeia and rhyme. The thesis has a *prima facie* plausibility: rhythm emphasises the temporal form of discourse; onomatopoeia its material basis; and rhyme, an echoing of the materiality of language, both draws attention to that materiality and punctuates (and so makes explicit) the temporal form of the discourse. Together these devices increase the interaction between the moment and the linguistic and intellectual form unfolding in time. In this way, the abstract idea is more deeply embedded in the material of its representation.

So there *is* a quarter-truth in Jacobson's poetics. Unfortunately, presented as the whole truth about poetry, it becomes three-quarters untruth as well. The quarter-truth of Jakobson's ideas

overlap with my thesis. It is possible to see the fusion between abstraction and token particularity, between absent general referent and present sounds in poetry, as a (rather modest) realisation of the fusion of sensory experience and knowledge. At any rate, it makes comprehensible the notion that, of all the forms of literary discourse, poetry is closest to music. 'The music of poetry', however, remains a complex and vulnerable concept that cannot be identified solely with the organisation of verbal sounds but must be related to the interaction between the latter and the organisation of ideas. *Pace* Stephane Mallarmé, poetry is made with ideas as well as words. As Valéry, Mallarmé's greatest disciple, said, a poem is a 'prolonged hesitation between the sound and the sense'. Any suggestion that poetic music resides in its sounds alone can lead only to the conclusion that poetry is a rather low-grade instrument, with a range somewhat short of that of a penny whistle. Moreover, despite Jakobson's claim, poeticalness is not co-terminous with literariness. There are many literary forms – most notably the novel – where the material tokens of language are not foregrounded. In the novel, as in most prose, the words on the page are almost inaudible (except when we are invited to imagine and so hear the accents in a piece of dialogue): we see what is meant rather than hear it.

In short, non-referentiality and total autonomy are *not* a condition of art or even of great art. The non-musical arts, importantly, state as well as suggest. The proportion of statement to suggestion will vary from art to art. What is merely suggested in a portrait – a whole life ('Thus is his face a map of days outworn'), a tone of soul, a social or historical context – may be made explicit and unpacked in a novel. Of course, no art will pandiculate: what is said will always be surrounded by a nimbus of the unsaid. A leaf-by-leaf account of a forest is not the way of the artist.

The art of referential art is to gather sufficient particular experiences together to embody the form; to show forth the idea through experiences. The Cornwall we could not arrive at is captured by glancing references to the cliff path, the trajectory of the ball as it heads towards the sea, the dropped ice cream, the sandy footmark in the cottage doorway, the moonlit foam, the delighted or crying children, the moment in the filling station. Reading this, we share in the moments, in the experience and yet do not lose sight of its whole, or the sense of a whole. The things that we experienced in serial disorder are made to co-exist: 'Here Time becomes Space'. The river of succession – the moments that passed through us as a procession of inchoate and warring forms – broadens and deepens to a lagoon. Cornwall is at once experienceable in minutiae (so it is not a brochure abstraction) and known as a whole: the idea and the experience, the moment in time and the arrested form, are brought together and we, who could not arrive, arrive. The world is captured in a moment and the moment flowers out into a world – the world we could not, when we lived it moment by moment, grasp as a whole – so that we reciprocate its grip on us with a grip as strong.

Chapter 4

The Arts and Emotion

I have focused on the idea of form and so would seem to be empha-
sising the formal qualities of a work of art to the exclusion of all
else. I want to correct this impression and to relate the story so far
to traditional aesthetic theories and to the question of the variety of
the purposes and instruments of art.

There are four main trends in aesthetic theory which, respec-
tively, emphasise the following features supposedly distinctive of
art: form, imitation, expression and something called 'beauty'. Such
theories do not clearly separate the distinctive properties of artworks
from their function or the means by which they exert their power
and have their value. For example, the assertion that the essence of
art is imitation is ambiguous. Does it mean that art simply (descrip-
tively) is imitation? Or that the purpose of art is to imitate? Or that
successful imitation lies at the basis of the power and effectiveness
of all art? Moreover, the fourth theory is not necessarily additional
to the others. Beauty may well be simply the result of the imitative,
expressive or formal qualities of the work – the end to which the one
or more of the others are the means.

We have related the aesthetic impulse to a response to the the ideas, borne on anticipation and memory, on words and images, that underlie, drive and (because they are unrealisable) undermine the moment of experience. The challenge of art is to realise, to embody, large forms. Whereas in music, the forms are additional objects in the world – they are made out of music – in visual art and literature, the forms are, directly or indirectly, made out of or utilise the given substance of the world: the art refers to the world and the world feeds into the art. This is not to suggest that in these more-or-less representational arts, the end is exact mimesis of a piece of the world; for in that case Camcorder Man would be the supreme artist or (as Plato scornfully suggested) a mirror would be all that was necessary to turn oneself into an artist.

It is important to appreciate the limitations placed upon the mimetic aim. All art is mediated through materials and through conventions. There are the basic conventions – such as the conventions that govern the ordinary use of words in language or the translation of three-dimensional space on to a two-dimensional surface with brush-strokes in painting. These basic conventions may be to a lesser or greater degree arbitrary. Self-evidently, Michelangelo's *David* is composed of less arbitrary signs than a poem: the word 'arm' is more arbitrary a sign than the iconic sign of David's arm in the statue. And in addition to these basic conventions (which are also used outside of art), there will be secondary conventions – mannerisms of depiction, metrical rules, etc. The work of art cannot for these reasons be a transparent window on to a bit of reality in virtue of replicating it, even if that were an aim. Literal mimesis, in the sense of precise imitation based on replication more or less of the physical properties of part of the world, is only a small part of what even referential art is about.

Mimesis *per se* may intensify our awareness of the object –
and so locally heighten consciousness – but this will not be a result
simply of representation or re-presentation. After all, we are sur-
rounded from morning till night by representations of objects:
almost every visual field is littered with pictures. In order to intensify
consciousness, representation has to gather up into the object or
event or situation or corner of the world its implicit significance, or
somehow make it significant. In visual art, literal mimesis is tran-
scended in two directions: the object may be transformed or played
with to make both it and a style more evident; and it may be made
to stand for a whole class of objects. In fact, the metonymic function,
whereby the represented object is made representative, has a vertical
and a horizontal dimension: a face, a street, a hay-wain may typify
a whole class of faces, etc. – this is the vertical dimension; but it may
also stand for the way of life, the life, the world, from which it is
drawn. A street scene *becomes* Paris in the 1800s, becomes nine-
teenth-century Europe. (A commanding image may help itself to do
this by becoming emblematic – that which we think of when we
think of Paris, etc.) A depicted tree stands for an open series of trees
– and for the days and summers that surround them. The denoted
object invokes a world of connotation. This capacity to invoke more
than is represented may be exploited in art that deals in abstract
forms and patches of colour. The patch of brown paint that Roger
Hilton entitled *Liverpool Autumn* seeks to trigger a nexus of thought
and ideas. Whether or not it does this depends upon how much we,
the spectators, are willing to put in, the extent of our generosity or
goodwill towards the painting – the extent of 'the beholder's share'
that Ernst Gombrich spoke of.

The power of visual representation to go beyond mimesis –
so that a small canvas can suggest a world – is greatly exceeded by

literature where representation is mediated by arbitrary signs and we should speak rather of the expression of meanings of objects or of reference to objects rather than of representation or mimesis in the literal sense. (Though of course much of drama is mimetic in a very literal sense.) We are familiar with the idea of a writer invoking a world and this can, with an appropriate choice of elements, be achieved with remarkably few referents.

The world that is captured in the painting or the piece of prose has an explicit form, just as the small objects and events – the cats and the dogs and the journey across the road – in our lives do; but it is much larger than those small objects and events. It is as large as the ideas that we are unable to realise in our experience. The intrinsic, formal properties of the work of art and the compression of immensity into small spaces, work to ensure that the representation – with its metonymic power to stand for classes of objects and its controlled spread into a nexus of connotations – is mind-portable. The form through which the work of art is unified unifies and makes accessible to the moment of consciousness a great section of the world – equal to the ideas that haunt and hollow the experiences that can't realise them. This is the connection between the formal and representational aspects of art. They are not alternative defining features of art but work together to fulfil the function of art.

What about 'expression'? The expressive theory of art is multiply ambiguous. The theory may imply any of the following: art expresses objects, e.g. depicts them; art expresses (represents, exhibits) feelings of the artist and/or the recipient; art is intended to transmit feelings from the artist to the recipient; expressive power is the basis of the aesthetic value of art. In its commonest use, the expressive theory holds that art is about the expression of emotion and that the work of art is the vehicle by means of which the emo-

tions of the artist are transmitted to the recipient. The value of the work is to be measured by the completeness and precision with which the emotions are transmitted and, possibly, by the intensity and the moral quality of the emotions. How does expression of emotions relate to form? To answer this, we need a theory of emotions.

*

There are several things to be noted about emotions. The first is that they fill the world with meaning; when we are angry, delighted, etc., we are not oppressed by a sense of not quite being there. The second is that emotions feed on, validate, themselves: anger talks angry talk, delight finds more to delight in, love loves and so justifies itself. Although anger is fulfilled meaning, it is always looking for further meaning as it talks itself up and finds angry-making things in the world. It is self-perpetuating and, yes, in a sense, self-perfecting.

Despite this self-perpetuating element, emotions are not, of course, eternal. They are not immune to invasions from the outside world nor to spontaneous inner decay; but they are remarkably exclusive so long as they last. In its completed state, an emotion is (as Heidegger pointed out) a state of attunement, a mode of openness, to the entire world. I would go beyond this passive interpretation of emotion and support Sartre's suggestion that an emotion (far from being a local physiological tempest) is world-making, world-synthesising, world-organising. As Wittgenstein said, 'the world of the happy man is different from the world of the unhappy man': we make over the world as happy or unhappy. Emotion unifies the world. Even at the height of his emotion, however, the individual has a sneaking sense of its lack of objective validity: the angry man has an uneasy feeling that the universalising tendency of his anger is absurd – like Mrs Rooney's cry, 'Christ, what a planet!', when no

one will help her up the station steps in Samuel Beckett's *All That Fall*.

The meaning with which the emotion floods the world lacks objective basis, as we are aware when we observe others in the grip of an emotion we do not share or when we see others amused at our anger or bored by our stories of the outrage that has just befallen us. Although the emotion is a means of possessing the world, it is also something that possesses us: it is not entirely an expression of our freedom. It bears the stigmata of parochialism and triviality. And when we are not in the throes of ordinary emotion, we feel a hunger for more meaning, for deeper ideas than those which trigger, govern and feed the endless circuit of our usual, transient emotions – emotions we may wish to snap out of and will certainly, from the influx of events impinging upon our feeling-world, fade out of. Nevertheless, like art through its formal properties, emotions are unifying.

This bring us to the heart of the relationship between art and emotions: art, by inducing emotions, utilises a faculty by which consciousness finds in and imposes upon the world a greater unity than it has to the uninvolved gaze. An emotion promoted through art, a *disinterested* emotion triggered by others' representative experiences, by larger ideas, rather than by our own self-centred preoccupations, has the world-unifying property of emotion without the demeaningly trivial or local origin, and so may correspond to an experience as large as our ideas. As Whitehead pointed out, 'the cultivation of the emotions for their own sake' is one of the prime characteristics of aesthetic experience. But this serves the deeper purpose of art: to bring together more of the world in order to permit experiences that are large enough to correspond to the ideas that haunt us.

I hope that the foregoing makes clear that, although I have approached art through form, my theory is not formalistic in the

sense of underplaying the importance of other elements. Though it does give form a central explanatory role, my theory can take into account mimetic – representational or referential – elements as well as the emotionally expressive properties of art. The unifying idea is unity itself – unity over a large span of experience, making possible experiences that have the scope and clarity of those ideas that elsewhere undermine experiences by so greatly exceeding them. In referential art this is achieved by accessing a large part of the world unified by form and controlled connotation: we may think of a poem, for example, or a novel, as enclosing a vast hyperspace created by its many words that connect otherwise disparate experiences, memories, thoughts. Form may additionally operate through emotion to reinforce the unity of the space indicated (and so enclosed) by the work. The work consequently permits the integration of more of our experience into the moment of consciousness.

Moreover, referential works may give us access to different worlds, different minds, different lives and so extend our range of experience, permitting us to imagine into the experiences of others, as well as integrating our first-hand experiences. In the case of musical and non-representational visual art, form is yet more explicit and the signs, which fall back into themselves because they do not signify anything definite outside of themselves, have an enhanced and thickened presence. Music has an added power from being close to emotion and that emotion hints at an imaginary reality fabricated from elements of the listener's own world lit up by the feeling released by the music. In all cases, one is afforded a view over larger sections of one's experience and the world than ordinary experience usually permits.

It is thus possible to subsume the four major theories of art – the representational (referential, mimetic), the emotive, the formal and the theory according to which artworks are defined simply by

their quality of beauty – under one theory, based on form. The quality of beauty in art is the enlarged view that it permits us: beauty is a tor on the plain of consciousness. The formal, the mimetic and the expressive are not at odds; after all, ordinary utterances utilise a highly formalised system of arbitrary signs and these are referential and may be intensely expressive of emotions. (In the case of literature, the forms may range from single words, through sentences, through much larger, organised formations – such as stories and, ultimately, novels.) The formal elements permit unity and, through this, enable great vistas to be opened up.

There may be tensions between the formal and the representational aspects of art: fidelity to the chaos of ordinary life points in the opposite direction to the wish to give the work a clear form, and the use of much larger forms in which the organisational elements are highly explicit. Nabokov speaks of a novel being the product of a quarrel between the writer and the world. The public face of such a novel should, of course, bear no trace of that quarrel.

What both representational and non-representational art have in common, the condition towards which they *both* aspire, is that fusion of the actual with the idea of itself necessary to achieve the arrival that consciousness dimly intuits as its destination. We may think of fiction as occupying the middle ground between the pure, non-referential forms of music and highly specific referential forms such as representational painting. What literature loses in material presence – text on a page is hardly to be compared with an orchestra in full flight – it gains in the range of its reference.

It is in literature above all that the scatteredness of everyday life, the dissolution of arrivals into journeys, is redeemed. The Cornwall that eludes us in Cornwall, the holidayness of holidays that dissolves as we holiday, the beachiness of the beach that leaks away like water through sand as we play on the beach, is recovered in the

perfected memory of fiction that prompts us, the readers, to perfected memories of our own. It is in literature that we come closest to bringing together the cliff walk and the lost toy, the game on the beach and the waves smashing against the rocks.

A novel enables one to arrive in one's own life by invoking those experiences that one has not quite fully experienced and bringing them together in a way that they could not be together at the time. This does not require a hyper-realist replication of the remembered world; on the contrary, it is easier to achieve the synoptic view through a few well-chosen elements that mark out the distances the world contains, triangulation points that catch up the space between them. The art of literary depiction is to mobilise a vast complex of associations from which a world can be unpacked – like the universe gathered up in an aroma of recollection when sensation triggers involuntary memory.

*

Does reality, Proust's narrator wonders (Volume I, p. 201, of the Kilmartin edition), take shape in memory alone? If it does, it cannot be retrieved through voluntary memory. This lacks the synoptic powers of involuntary memory: it replicates mere details. As Beckett says, in his 1930 book on Proust:

> The man with a good memory does not remember anything because he does not forget anything. His memory is uniform, a creature of routine, at once a condition and a function of his impeccable habit, an instrument of reference instead of an instrument of discovery. The paean of his memory: 'I remember yesterday as well as today . . .' is also its epitaph and gives precise expression of its value.

Involuntary memory, on the other hand, while it is as fugitive as experience, is no mere replication of experience – on the contrary, it is a revelation of the world that was the implicit form or framework of that experience; it is transient and, by definition, eludes the grasp of the will. The experience of involuntary memory gave Proust the idea of what art might be, of what it might achieve. Involuntary memory reveals both the possibility and the necessity of art; the feasibility and the importance of its project. The sense of paradise lost and the sometimes delighted, sometimes anguished, intuition of the possibility of paradise regained (the two go together) gives the project of recovery its urgency and writing its content. Literature, which aspires towards a synoptic view over a world (so powerful that it seems, for a while, like *the* world) and is at the same time permanent, even objective, achieves what involuntary memory hints at. At its height, literature is an endlessly reinvokable involuntary memory; an ideal consciousness, an ideal experiencing, of the kind adumbrated in involuntary memory but brought under the ambit of the will.

Of all the arts, literature is closest to the special *repetition* of the past that permits experience to be recovered and so experienced fully in the way that it could not be experienced at the time. It is as if literary art discovers for us the *a posteriori* secular, immanent essences to which our experiences amount. The secular revelation (as opposed to the religious revelation of *a priori* transcendental essences) is the fullest realisation of what was there (or in the case of writers of loss such as Hardy, poignantly *wasn't* there), of how so many things belonged with one another, of the hidden nerve of association that held the world together. (There are artists in whom the secular and religious revelations converge, often with the former serving the latter: Bach and Messiaen, Raphael and Rouault, Dante and Milton.) In the secular revelation, the principle of unity of the

world is the synthetic power of the individual consciousness that holds so many disparate things together; in the religious revelation that preceded it, it was God. So, in the perfected memory of art, Cornwall rises up from the sea of preoccupations and particulars, like the sunken cathedral in Debussy's prelude *La Cathédrale Engloutte*, and we see it as we have never seen it before. Almost as a reversal of the process by which the Word was made flesh, the travails of the flesh are made Word. For Mallarmé this is the essential destination and ultimate glory of consciousness: *Tout, au monde, existe pour aboutir à un livre.*

At the same time, literature shares with the non-referential arts such as music the fundamental property – which is most powerfully exemplified in music – of bringing together material experience and an abstract overall form, so that the experience knows where it is going, knows what it is, and journeys 'arrivingly'. And only when we have lived our lives again in the perfected memory (or the perfecter of memory) called art have we truly lived.

*

I can see another source of resistance to my thesis arising out of my emphasis on the perfection of experience. If art is about the moment of experience, how does it differ in value from other moment-enhancers – for example, recreational drugs? This question has a particular force in relation to music; for it is closest to, say, drugs inasmuch as our encounters with it could seem to boil down to a series of unrelated ecstasies – an overture, followed by a concerto, followed by a symphony; a concert followed by a tape in the car on the way home; Bach last thing at night followed by Palestrina in the morning and Stockhausen at noon – which may seem like a succession of fixes unconnected with one another or with whatever else is

going on in our lives. Any connectedness would seem to be merely internal: the piece connects with itself in the process of realising its form; the realised form connects with other examples of the same or different forms.

It would be dishonest to deny this difficulty or that music can be consciously used, like a drug, to boost one's mood: 'the brandy of the damned' as Shaw rather grandly called it. And if, as Valéry asserted, the purpose of poetry is to have a certain effect on a reader, isn't poetry also simply a safer but rather less effective and reliable agent than drugs for altering consciousness – one suitable, perhaps, for those who are frightened of the police? The answer is obviously no, but it is perhaps less obvious why it should be no.

The purpose of art may be to bring about the perfection of the moment but, in order to do so, it has to bring together elements from many different moments: art is about connectedness. The elements of a work of art are themselves connec*ted* with one another in their co-operative effort to realise the form; but they are also connec*ting* inasmuch as they bring together otherwise disparate elements of the world. This bringing together may have many dimensions. There is the intertextual dimension, whereby the work's conformity to a certain genre (or its transgression of genre rules and boundaries) invokes other works of the same genre. More importantly, there is the connection between the work of art and its historical and social context. Our enjoyment of it is deepened by knowing something of this. This is more evidently true of literature than of music, but even in the case of the latter, appreciation (which goes beyond immediate pleasure) is enhanced by understanding, by knowledge, however scanty, of its context.

It is more obvious that we cannot understand a poem without connecting it with many other things, and so without mobilising

our own implicit internal connectedness, the connectedness of our experience and knowledge, and our potential for a wider and larger sense of things. In literature, of course, this connectedness will be occasioned by the referents of the work: a reading of a novel may bring together vast tracts of our lives or of the world by awakening a complex of associations. A great poem is a realisation of Blake's contention that every thought fills immensity: it unpacks that immensity, or makes it available, by compressing much into a small space. (Profundity could be defined as 'compacted immensity'. Compare the German word for poetry, *Gedicht*, 'condensation'.) So in order that art should work on us and enable us to realise these connections in our life, we have to work with it. Art does not invite us, as do drugs, to escape and oblivion but prompts remembrance, recollection, reflection and wakefulness. The awakened and self-wakening, the actively imagining consciousness of an individual yielding to and possessing a work of art is utterly remote from the drowsy passivity of a drug addict succumbing to another fix.

There is another crucial distinction between works of art and recreational drugs as perfecters of the moment, as bringers about of effects. Although both are causes of altered states of consciousness, only the work of art is the object of the altered state, as well as the cause of it. The novel that intoxicates us remains the content, the object, the referent of our intoxication; or its content mediates our access to the referent of the intoxication. The work of art does not disappear without remainder into its effects on us. By contrast, the drug effaces itself in its effects (unless something is going wrong – the bad trip; the sixteen pints of beer that are ominously reasserting their independent existence and imminent likelihood of return): it is not the *intentional object* of the altered mood it invokes. The work of art is not merely the cause or agent bringing about my

altered state but its continuing rationale. There is a great difference, indeed a great distance, between a cause and a rationale. The effects of the work of art – the moods, the thoughts, the memories – refer back to the work itself. This distance is greatly increased since the work itself has referents: the referents of the effects of the work also reach back into the work.

Since its referents tend to be inward, music seems closest of all the arts to drugs in being a bringer-about-of-effects unrelated to the outside world, a perfector of the moment that threatens to collapse inwardly into referenceless or randomly referential intoxication. Literature seems less prone to this danger. There is always, to a lesser or greater extent, a further consequence of the encounter with a work of literature which is not merely a jewel to be admired but a lens to transform one's perception of the world – this is the sense in which, as Auden says, 'great books read us'. This effect on the reader may be accompanied by a loss of authorial control over his or her response. The sentiments invoked by a novel and regulated by the author's unsentimental vision may, when they generalise across the reader's world, degenerate into mere sentimentality, free of the connectedness that confronts emotions with their consequences and their cost. Nevertheless, this impact is still channelled through, and regulated by, the referents of the novel and so is subject to a certain amount of 'quality control' by the author. The consequence of reading *War and Peace* is unlikely to be a solitary and ecstatic contemplation of the back of one's hand while others around you are going through hell.

The perfection of experience in all arts is always associated with *some* disconnection from the outside world – the world of responsibility and of concern for and relations with others – which is one of the reasons why any claim for the moral effect of art must

be treated with the utmost scepticism. The gaze and attention of a person reading a novel or a poem is averted from the reality current in the outside world, though not as completely, as would be the case of the drug taker who settles for a series of isolated moments, of ecstasies unconnected with everything else in his life: 'little doses of oblivion'.

Art and Transcendence

The world transcends our experiences. The objective reality we perceive has several characteristics but two seem to me worth reiterating: it has the form of a *possibility*, which is of a general character and thus approximates to what is ultimately captured in words (which assert, deny, etc. general possibilities); and it is *public*, that is to say it is equally and explicitly available to all. The notion of reality that is available to others as much as one's self (and may be available to others when it is not available to one's self and vice versa) is the linchpin of the human condition of living in an acknowledged shared world. It is the foundation stone of a genuine social existence that is rooted in a sense of having a common arena for potentially shared experience.

Other animals, such as so-called 'social' insects like bees and ants, may have dovetailing automaticities, but they are not truly social, for their interactions are largely prescribed and instinctive: they are not deliberate, intended, willed, calculated or understood by the participants. Humans, by contrast, interact on an illuminated stage that is built up out of mutual acknowledgement. They have a genuine common space made of intersubjectivity. This public space

is not merely the physical space in which the human organism is located, but a beyond, which is distanced from, and has characteristics different from, the space in which all non-human creatures interact with the physical world and, via interlocking mechanisms, with each other. There are many expressions of this: artefacts, artefactscapes such as cities, institutions, laws and principles, modes of discourse and so on. These constitute a theatre of deliberate behaviour, of actions that could not happen without the actors being aware of their purpose, of a world of possibilities which they intuit and try to shape.

The most elementary building-block of this shared space, requisitioned with each new entrant, each developing infant, is the interaction of the gaze, where each sees that s/he is seen by others and that the other sees. We are unique among the primates, as Daniel Povinelli has demonstrated, in having a sense of the other person as seeing, as having a viewpoint. When we see that another sees, this visible seeing reveals another kind of hiddenness: the psychological state of another person and the possibility of a different or parallel world as revealed to another's gaze. The psychological state of another person is a deeper interior, a more esoteric 'darkness visible', than the interior of an object or the objects round the corner.

Pointing grows out of this joint attention into a shared visual attention to objects that build into a shared world, a public reality, an interpersonal arena for true society. By this means it inflates the bubble of available common reality in which humans operate. We are not (as are other animals) sentient monads interacting with, but inwardly sealed off from, each other, solipsists in practice without the notion. We are participants in a collective consciousness.

Of course, in the developing infant, pointing is very soon overshadowed by language in the narrow sense of speech, and is caught up in the world that words articulate. For this reason its

significance is overlooked. Pointing is a gesture of supreme importance, of itself and for what it reminds us of our own nature. If one subscribes to the idea that language originated out of gesture, then pointing, as the most versatile of all gestures, and the one that seems closest to the primary, that is to say the referential, function of language, is, we may argue, crucial to the beginning of truly social being (of a kind unknown elsewhere in the animal kingdom), of a collectivisation of consciousness upon which community, discourse, civilisation and knowledge are based.

The reinforcement of joint visual attention by pointing, and the invitation to another to attend to something of which she was unaware, and checking that she is aware of it (as infants do from very early on), or whose significance she had not appreciated, or which lies outside her current sensory field, is a huge step in affirming a shared world and a world which includes things of which we have no understanding, which provoke us to further our understanding. It is to this that humans owe their unique power to dominate the natural world and, indeed, to create a parallel human world of artefacts and laws that are additional to, or displace, or are at odds with, the laws, processes and products of nature. We put our minds and bodies together to have effects that dwarf even earthquakes.

Pointing is a fundamental action of world-sharing, of making a world-in-common. It not only tacks that common world together; it also expands it, and the two processes are not separate. When you are pointing to an object that I cannot see, and which is actually beyond the horizon of my visual field, you are affirming the existence of a world lying outside of what I can sense. You are affirming possibility beyond actuality by pointing to a particular possibility that I cannot see. The boundless 'Beyond' is what lies through the doorway leading from indexical to deindexicalised awareness, glimpsed through the oriel opened up by your index finger.

Of course, we are aware of things (events, states of affairs) that are not there before us – possibilities no longer realised, possibilities yet to be realised – without the assistance of pointing: we recall and we anticipate. What is special about pointing is that the items pointed at are not only explicit but also *shared* possibilities, or, rather, what is actual for one person is proposed as a possibility for another. Pointing is a fundamental instrument in the socialisation of possibility. It makes the beyond explicit and makes it something shared.

The power of indicative gestures to awaken this sense of shared possibility is often compelling. A man standing in the road pointing at the sky will soon attract a crowd wanting to see what it is he is pointing at. This prank – and it sometimes is a prank – exploits the fact that pointing is, in the overwhelming majority of cases, to something that exists and which, moreover, the producer has reason to believe will be of interest, in particular to the consumer. He may believe this because it is of general interest to most people, or it may be of very particular interest to the consumer in question.

The possible, or the beyond, in which pointees lie has two dimensions, temporal and spatial: there are things that lie out of sensory range but are current; and things that are not-yet or no-longer. It seems that the out-of-sight (or out-of-sense) is the fundamental mode of the beyond: its 'not-yet-ness' or 'no-longer-ness' is set out in space. We have the sense of something coming (an emergent possibility) or of something going (a lost possibility) inscribed in the passage of things towards us or away from us. Pointing, which points to possibility, reaches into both dimensions at once. When you point to something you can currently see and I cannot, the pointee is located not only in a spatial beyond but, so far as I am concerned, in a temporal beyond. You are pointing to a future experience I might have if I follow your instructions to attend.

With the assistance of language, of course, pointing may be more explicitly tensed, as when I point to an empty chair that was once occupied by someone who is no longer. The great emblem of Communist countries – that of the leader pointing towards the future – is extraordinary: the pointee is an entire (happier, better) state of a nation, to be arrived at, and located in, a non-specific future. Indeed, this is so general that the act almost turns in on itself and simply becomes a sign of itself – or of the kind of country in which charismatic, autocratic, brutal leaders remain in power by pointing to a better future and liquidating those who do not share their vision or buy their rhetoric. Be that as it may, it is in this realm of shared attention, of a community of minds, unique to humans, that art takes root. It arises out of the transcendence built into individual consciousness and the endeavour to go beyond it, to reach for a further transcendence.

<p style="text-align:center">*</p>

Art has often been used to glorify, divert or pleasure those who commission or pay for it. This has made people cynical about the claims of art to express transcendental values. Artists know they must follow the dinner pail or end up dead next to an empty one. But the extraordinary thing about great artists is that they have produced works that are many times more beautiful, profound and complex than their contract required. The luminous intelligence, the miraculous imagery, the ravishing music of Shakespeare's language is astonishing when one considers the inattentive, malodorous, noisy philistines who placed their Elizabethan bums on the seats. This tells us something about artists – and about humanity.

Art, in particular literature, has a significant civic element in the broadest sense of inviting participation in a wider social discourse that points to a collective experience, a shared memory and

concern, so that its referents extend beyond any individual's present moment. Of course, it is easier to say this than to determine the limits to which art should refer to, and assume, and be subsumed within the public domain. Art that is widely appreciated (as opposed to art as 'therapy' for the artist, which has many makers but few takers) must be in touch with a common or collective element in experience. That a work of literature can recover, and so perfect, the experience of an individual artist and yet speak to many different recipients – so that it seems to them to have an objective authority as well as a personal resonance – is not as paradoxical as it sounds. Even in our depths, much of our sense of self is communally derived (though the temporal and spatial extent of that community is a matter of considerable contention and the degree to which the self is a communal product is a key issue in contemporary thought); consequently, at least a part of deepening self-consciousness will be heightened consciousness of others, or of collective experiences and value.

There is danger in assuming an identity of the private and the social self at too superficial a level. This is perhaps evident in some aspects of Augustan poetry where satire, social observation, the use of more or less abstract concepts in more or less philosophical discourse, are dominant, and the overriding values are intelligibility, clarity and what has conventionally passed for logical order. The danger is that of an art that is too external, too wedded to the forms and assumptions of a certain area of and epoch in public discourse, too second-order, too composed of pre-packaged elements of thought and feeling, too remote from the uncombed chaos of actual individual experience. True Art may shrink to 'True Wit' which (according to Pope's *An Essay on Criticism*) is

> . . . nature to advantage dress'd,
> What oft was thought, but ne'er so well express'd.
> *II. 297–8*

This is a vulnerable and extreme articulation of the valid assumption that art has deep social roots and that the inner world articulated by the artist is the outer world of the society to which he or she belongs, so that art is committed to elegant re-expression of the well-known, the self-evident, the taken-for-granted.

> Something, whose truth convinc'd at sight we find,
> That gives us back the image of our mind
> *II. 299–300*

is a prescription that may imprison art in the received ideas of its time and encourage too superficial an identification of the inner recesses of the individual consciousness with the outwardness of the public domain. The prescription of an art that will be immediately accessible to everyone and will touch in the prescribed manner on issues that are laid down as being of central importance was more consciously and more systematically imposed in the totalitarian regimes of the twentieth century. Its only outcome has been the elevation of right-thinking mediocrities and the persecution of geniuses.

Nevertheless, if writing originating from a stranger is to re-connect disparate corners of the selves of strangers, bringing together many separate moments into a moment of synoptic vision, it will have to reach into many corners of the objective, external world, however 'expressionist', 'anti-classical', 'imaginatively dissident' or 'Dionysian' the work may seem or aspire to be. (And no art is as Dionysian or anti-Apollonian as a fight in a street.) Besides,

there is a large space between, on the one hand, incoherent gibberish expressing in 'the language of the self' experiences and connections between experiences that have only personal significance and, on the other, the reiteration in ever-more polished language of reassuring commonplaces and received ideas. This is an adequate space for literary art to find, and endlessly renew, itself.

So, although art attempts the perfection of consciousness in the perfection of the moment, this perfection partakes of more than the moment. There are the objective elements of structure which reach across the work, which outlast the moment, and out of the work to the genre to which it belongs. These alone ensure that the work points beyond the recipient and transcends the moments of his experience. The essential synoptic genius of the great works means that engagement with art, far from being merely a succession of experiences, is a liberation from the ordinary condition of life that threatens to be a succession of experiences that do not realise any larger conceptions. Notwithstanding that even the experience of art is inescapably episodic (we listen to the symphony and then catch the bus and return to our worries), it is less completely so than other experiences – with the exception, perhaps, of those by which we are unwillingly possessed, such as chronic pains, persistent anxieties and nagging responsibilities.

Of course, the aesthetic experience in some sense remains a matter of moments. But then this is true even of religious experience. Kierkegaard observed that

> it is only momentarily that the particular individual is able to realise existentially a unity of the infinite and the finite which transcends existence. This unity is realised in a moment of passion.

He adds that

> modern philosophy has tried anything and everything
> in the effort to help the individual to transcend himself
> objectively, which is a wholly impossible feat; existence
> exercises its restraining influence. *Kierkegaard, Conclud-*
> *ing Unscientific Project, translated by David Swenson and*
> *Peter Lowrie (Princeton University Press, 1944)*

There are moments that reach out and touch other moments, moments that are uniquely infused with something that goes beyond moments. Such are the moments afforded by the encounter with great art. The world we are in, by which we are possessed, into which we are dissipated, the very framework within which experience takes place, enters us and we see the moment from a perspective that, although distancing, does not alienate us from experience.

Because the experience of art is, even so, of the moment, there is no 'before' and 'after' art, with permanent gains and lasting salvation. The experience has endlessly to be renewed in different ways. Art, we may say, offers intermittent or temporary relief from the permanent condition of not quite being there. Nevertheless, works of art are not merely experiences to be had, jewels to be contemplated, but also lenses to alter perception; a great work of art is boundless in this sense and its effect is by no means confined to the moments of its consumption. Indeed, one does not consume art in the way that one consumes other goods of the world. A great novel cannot be consumed in the way that an airport paperback can be consumed. It is inexhaustible, reaching beyond what we can encompass in a single reading; and, in that sense, it consumes us.

*

Anyone with the slightest historical sense may be prompted to object: what you say about art has nothing to do with its function in cultures and times remote from the here and now; that, even though art does sometimes have as its purpose the perfection of the present moment of consciousness through the fusion of idea or form and experience, this is, howsoever important, only one of its many functions and, in the case of much art, or art in most historical epochs, not a central one. We have, it seems, avoided the trap of asserting that all the arts are the same only to fall into the even greater trap of asserting that art has a central function which is the same for all peoples across all ages.

Historically, artists, it will be emphasised, have less often been concerned with the perfection of the moments of experience, the healing of the flaw in the present tense, than with, say, instructing their fellow men – morally, politically, and even practically. (Not to speak of those who have been driven by other, less altruistic impulses, such as dazzling their fellow men, exacting revenge or earning a living.) Writers, in particular, have often been possessed by a social mission, by an urge to right perceived injustices in society or to reaffirm forgotten values. A multitude of intentions and needs and purposes may be evident in or served by the writing and reading even of a single work – or a single page. At any rate, art being a supremely social activity has always been embedded in other things as well as being profoundly influenced by the technology through which it is expressed. (Archimedes, Caxton and Edison have had at least as much influence on the course of art as Euripides, Michelangelo and Goethe.) Consider just one art: music. It may have started with crooning dialogues between mothers and children or been inspired by a desire to emulate birdsong – perhaps in the hope of learning the secret of flight in soaring melodies! It has been a branch of mathematics and physical science (acting in the service

of the ancient dream of accessing heavenly harmonies and finding the very substance of the world). And it has been used as an adjunct to warfare, to courtship, and to the major and minor ceremonies of the tribe.

Perhaps the strongest element in the case against any universal theory of art is the changing relationship between art and that other great expression of our endeavours to make sense of our lives, to find a place where 'all our compulsions meet / Are recognised, and robed as destinies' (Philip Larkin, *Churchgoing*), our metaphysical (and, alas, other) impulses – religion. Art was at first not clearly separated from religious ceremony, the invocation of the gods and their appeasement. Music and dancing were most fully elaborated as an integral part of religious ritual. Greek tragedy, the ancestor of much literary art in the West, emerged from the annual Passion of *Dionsysus*, 'the ritual play in which the *dromenon*, the thing done, was the sacrificial slaughter of the god, either in human form or as a bull'.

When art did become distinct from religious ritual, its main themes were religious and its function was to serve religion and, through this, celebrate, reveal and elaborate the power and glory of the gods – or God. This remained true from the Dionysian tragedies of the Greeks, through Byzantine and Islamic painting, to late mediaeval art, whose exponents were the anonymous servants of the Church. It was only with the Renaissance that the making and enjoyment of art crystallised out as an activity entirely separate from religion. Human figures and perspectives seemingly true to actual human perception increasingly displaced religious figures painted in a conventional, iconic fashion that had little to do with sensory experience. Although religious themes remained important, they were approached increasingly from the outside until, by the twenty-first century, they have been reduced in many instances simply to a

means by which an artist may confer greater resonance upon his work or measure his distance from the past.

There are many ways of characterising the journey of art away from religion. Here is one trajectory. With the changing theme and function of art, the artist emerged as a creator in his own right and his work was increasingly related to a source of secular patronage: he painted to commission. When patrons were kings and aristocrats, there was still a remote connection to religion, not only through the conventional commissioned themes but also through the convergence of upper state and Church, most explicitly in the divine appointment of kings. With time, wealth rather than title became the defining characteristic of the patron. The divine appointment of Moneybags was less easy to sustain. The demystification of the patron and the romantic rebellion against the standing and values of the ruling class reinforced one another and paved the way for artistic resentment at the untalented power-brokers to whose commissions artists worked and the emergence of rebellious, egocentric, even demonic, artists as antipodes of the anonymous Gothic craftsmen. The artist served inner gods remote from, and at odds with, the society in which he found himself and its secular and sacred gods. The divorce of art from religion was completed in the separation of the artist from the very society which sustained him. This was particularly clearly evident in the evolving self-image of the French poets of the nineteenth century. The proud and sterile isolation of the 'knights of Nothingness' (as Sartre dubbed Mallarmé and some of his fellow Symbolists) emerged as a result of the interaction between the continuation of the romantic dream of the poet as *mage* and an increasing scepticism towards the social mission of the artist (and the humanitarian optimism as regards progress that lay behind it), a loss of faith in man and god and a hatred of vulgar reality.

Music, perhaps, was secularised earlier because it travels more easily: it can be overheard. As early as the sixth century BC Terpander ('the father of Greek music') promoted individualism against convention. The interpreter of a tradition intimately associated with religion metamorphosed into a virtuoso whose primary concern was to give pleasure to an audience. His individual take on the traditional melodies meant that they were handed down as his personal compositions. Even so, 'serious' music – or highly organised musical occasions – intended for edification and entertainment is relatively recent. There were no purpose-built music rooms in London until the end of the seventeenth century. And music for pleasure as we now understand it – serious music as readily and widely available as humming or drunken singing at a party – has been dependent on advanced technology: the privileged experience of the king and courtier is now available to all. Indeed, the privileged condition may now seem to be to escape it.

The evolving relationship between art and religion may be seen more clearly in the case of painting perhaps because, unlike music, paintings, until recently, did not travel: they could be seen only in the places for which they were commissioned. The development of a secular literature was slowed by another constraint on dissemination: the requirement that those who enjoyed it should be literate. It remained therefore largely the province and privilege of the aristocratic and priestly castes (and the latter's successors, independent scholars) until literacy was more universal.

The great journey from the undifferentiated participant in a religious ritual to an assertive individual who, according to Sartre, writes only for himself is a measure of the distance art has travelled from its origins in religion. This distance is not cancelled by certain set-piece attempts to return art to its ritualistic beginnings in carefully timetabled presentations in subsidised theatres: there is an

entire world and several millennia of evolving self-consciousness between helpless and unreflective immersion in the terrors and ecstasy of ritual and attempts to revive it in the Dionysian frenzies of the Theatre of Cruelty supported by the Arts Council.

Anyone, therefore, who believes the function of the cave paintings in Lascaux to be the same as that of a novel by Virginia Woolf, a poem by John Ashberry or even a painting by Jackson Pollock is obviously deluded. My thesis does not require subscription to this delusion. As we follow art in its crystallisation out of religious ritual – as when, for example, the ritual is formalised in liturgy and liturgy gives way to drama and the *Missa solemnis* becomes oratorio – and observe the displacement of explicitly religious values by aesthetic ones (with some harking back to the transcendental validation of religion), and the ebbing and flowing of the emphasis on fun and entertainment and the parallel fluctuation in the relationship to the patron, we see mighty transformations of the contents, the function of and the discourse about art.

The function of art that my thesis emphasises – the perfection of the experience of an individual considered in his or her solitude – is individualistic. To reiterate, it would be absurd to suggest that this has always been its function and perverse to deny that art may have begun as something quite different. Tribal poems and chants, Homeric narratives, the psalms – these are communal not individualistic, and the 'recipient' is not so much a consumer as a participant, one who is immersed, engulfed, consumed. It is important to recognise a past in which art was inseparable from the religious response to the terrors of life that, for example, gave birth to the Dionysiac rituals designed to help men to forget their solitude in the face of death, physical threat and the infinite heavens. But to concede this is only to say that art has its roots in something quite different from its more recent and more familiar manifestations.

There is as little connection between tribal chants and a chamber concert as there is between a rain dance and a grant application to the Science and Engineering Research Council. How far cultural activities should be governed by memories of their roots is a difficult issue. But, as things stand, art is far from its religious and ritualistic and communal origins and a theory of the purpose of art today should not have to pretend otherwise.

Admitting this does not require that I give up my thesis, only that I should not pretend that it is universal. Mine is not an account of what art always has been and should always be, of the eternal essence of art. More modestly, it is a theory of what art is now, with the scope of 'now' remaining undetermined, but it encompasses at least a century or two. And it is linked with my position that the social functions hitherto attributed to art – religious, moral, political, educational, informational – are now, in the West at least, secondary. If there has been a time when they were central to the purpose of art, this has now passed.

There is a curious inverse insularity associated with the belief that one's appreciation of art should be able to extend to all cultures throughout all of history and that one's tastes should encompass 'alien' art. This is a modern view that arose first in certain economically dominant great cultures that penetrated the world and, alongside the imposition of their own mores, values and aesthetics, expropriated those of other cultures to swell the collections of art galleries and museums; and secondly out of the development of technology that permitted the emergence of Malraux's 'museum without walls' and the great multicultural jumble of bric-à-brac to roll pauselessly through the eyes, ears, hands and minds of the cultured. It is not a view that would have been tenable in any previous periods of history. Few Sumerians would have flocked to Indonesian music festivals; the Greeks would have known little of West

African culture; there is no record of the literati of Baghdad in the sixteenth century fighting over copies of translations of Shakespeare. The cultivation of the art of other cultures and the emphasis on the 'otherness' of art is new; and it is a response to a sense that the otherness has gone out of life. The gods no longer terrify us; we are sealed in a four-dimensional continuum of unremitting rational explanation; the world, as Max Weber said, is disenchanted. But it is no less terrifying: the threats we face, most notably the ultimate threat of death, remain.

*

It is hardly to be expected that there should be a single, for-all-time answer to the question of the function of art. After all, 'art' is not a simple concept: it may be best thought of as a complex or nexus of ideas, corresponding to a multitude of creative activities. Moreover, the attempt to determine the purpose of art may have more than one motive. It is not impossible, for example, that a theory of the function of art may be as much a statement of what one thinks art *ought* to be, or of what one would like it to be, what one would like it to do for oneself, as an account of what it is or does or is generally accepted to do. The term 'art' is a place marker that holds open a certain amount of territory available to be quarrelled over by all sorts of worthy causes and high principles. It is a rallying cry or a forming-up position for rallying cries: 'Art is the collective's deepest mode of self-discovery'; 'It is the light that leads the way to a more just society'; 'It is that in virtue of which self-completion is possible'; 'It is a means of reasserting the shared values necessary to maintain the cohesiveness of society'. This is what it is . . . or what it should be . . . or what I should like it to be . . . etc. The distinctions are blurred.

Anyway, I concede that my thesis has a limited historical scope. The question arises as to whether my emphasis on *the* moving unmoved of form can accommodate the more recent past and the present – modernist art, which emphasises the decay of form, and post-modernist art, which takes this for granted and mockingly mixes incongruous forms. An obvious response is to argue that works rebelling against traditional forms and defeating expectations based upon previous aesthetic experience are themselves asserting new forms and making possible new aesthetic experiences: anti-forms are the emergent forms of the future, for it is the way of art that the form of its forms will change.

The trouble with this easy response is that, by recuperating all deviation from form for form itself, it makes the theory invulnerable to disproof. It is better, perhaps, to point out the empirical fact that the subversion of form is only a small part of the current pre-occupation of art. Much contemporary music, for example, is concerned with explicitly developing new forms which, like the old, are based on symmetries, contrasts, etc. (though utilising a greatly extended portfolio of acoustic possibility) – sometimes, one is tempted to think, to the exclusion of pretty well everything else. Formal organisation is central, for example, to Stockhausen from *Kreuzspiel* onwards, to Messaien, Boulez, the West Coast Minimalists, Schnittke, Harrison Birtwistle ... Admittedly, in some cases, it is easier to find the form in the programme notes than in the music, and it seems less a matter of *forma informans* than an exoskeleton or a *post hoc* rationalisation.

In this century, poetry has often seemed to teeter on the extreme verge of form, in the littoral zone where organisation gives way to a stochastic series of elements matching the randomness of thought, public events, private recollection and present experience, where structure crumbles to bric-à-brac. Even so, there is an implicit

invitation to discover form in, or impose form upon, the scattered fragments; we are offered, that is to say, an 'open form', or an assemblage of disjunct items that we are at liberty to synthesise into a unity. Examples that spring to mind include Great Moderns like Pound as well as more recent figures such as Ashberry. Of course, the appreciation of these open forms depends upon previous experience of closed forms. The closure is provided by the reader whose previous experience has led him to expect a completed form. Such works are not as simply parasitic as the effect of the following

> There was an old man in a tree
> Who was horribly bored by a wasp

is upon the expectations trained through exposure to a thousand limericks. No; they play at a much deeper level with the expectations or organisation and unity; they reach beneath a critique of art to an exploration of the aestheticising and organisation principles in consciousness itself. But they are, nevertheless, in some sense secondary. They remain forms that rely upon challenging or mocking the expectation of form. And, although they examine our idea of form, many modernist (and even more post-modernist works) merely allude to forms and in this sense fall short of the requirement to 'make it new' – to make new harmonies out of old dissonances, new expectations out of old surprises, new conventions out of old rebellions.

The theory I have put forward, therefore, while not pretending to be a theory of the eternal function of art, is applicable to the recent past, to the present. I also believe that it may apply to the artworks of the foreseeable future. Only a megalomaniac or a *maître à penser* could hope to do more than that.

The Uselessness of the Arts

That art is largely useless, especially in the present time, is almost self-evident and yet, when stated baldly, this is a view that will meet considerable resistance. Art lovers and artists – painters, musicians, dancers, above all writers – experience its inutility as a scandal which should preferably be hushed up. But it cannot be denied. If the ultimate criterion of the use of an activity for an organism is survival and for a conscious organism survival in pleasure rather than pain, then art signally fails to justify itself on either count.

Consider, first, survival. Was anyone's survival threatened by cutting off the Bach supply? Matisse does not cure chest infections or solve the problem of finding something to eat. No poem of Holderlin made the roads safer for children. Literature was once, perhaps, an important source of information, though it is difficult really to believe that farmers ever consulted Hesiod or *The Georgics* for practical advice on muck-spreading or milking a cow with mastitis. At any rate, it no longer has this function; and sculpture, dance and music never had it anyway. As for information about what is going on in the world at large – journalism provides better and more reliable coverage than poetry, fiction, cantatas, ballet or abstract

paintings. Art has even lost its function as an instrument of social cohesion – as a successor to myth or as a servant of religion – and so as an indirect force for survival.

Art may contribute little to survival but doesn't it help to make life less painful and more pleasurable – 'more enjoyable or more easily endured', as Dr Johnson suggested? Possibly. But it is not clear that it is more potent in this respect than ordinary companionship, alcohol or other recreational drugs taken in moderation, or even entertainments that might be dismissed as 'empty'. And when it comes to dealing with toothache, to take only a homely example of the pains that tip the account of consciousness into deficit, codeine has much more to offer than even the most engaged reading of Shakespeare's sonnets.

Millions throughout history have lived without art, few without love and none without food. The essential scandal of art is that it presupposes that the material problems of life have been solved (or can be shelved or are unimportant). This is why opera houses and poetry readings and classes on Velázquez have always been an embarrassment: there has never been a time when it has been anything other than bad taste to devote oneself to painting or music or poetry; there are always more pressing things to be done, such as saving starving children from premature death.

Tolstoy tells the story of an aristocratic woman at the theatre weeping at the imaginary tragedy enacted on the stage. At the same time, outside in the cold, a real tragedy is taking place. Her old and faithful coachman, awaiting her in the bitter night, is freezing to death. The point of Tolstoy's story is obvious: art does not necessarily make people better behaved, or more considerate. The woman was a hard-hearted bitch and art served only to deceive her as to her true nature, to give her the impression that she was a sensitive soul.

The dissociation between the experience of art and a propensity to good behaviour angered Tolstoy. He would have had no difficulty in accepting that art was of little use in solving the problems of hunger and material need but he could not accept its uselessness in the practical world of relations between people. Art that did not promote morality was not worthy of the name. Art was worthless if it did not conduce to good behaviour. The distinctive greatness of the artist lay in his power as a moral teacher.

In *What is Art?*, he savagely attacked what he perceived as the contemporary reduction of art to a mere amusement, recreation or opiate for the leisured classes. Against this, he asserted that 'art should be an organ co-equal with science for the life and progress of mankind'. And he defined art as an activity by which a man 'infected' his fellow men with feelings that he had himself experienced. The purpose of aesthetic form was simply to ensure that those feelings were transmitted effectively. Art should be judged not only according to how well the feelings were invoked but also according to the quality of the feelings themselves. Great art, which must be accessible to and significant to all men, to peasants as well as to the idle classes, transmits feelings that draw men together in brotherly union.

By these criteria, most of the art approved by his contemporaries could be dismissed: not only the works of Baudelaire, Wagner and Ibsen but much of Beethoven, Bach and Pushkin belonged to the category of bad art. And by the criterion of simplicity and accessibility, his own incomparable novels, whose greatness lay at least in part in the delineation of the complexity, ambiguity and vagaries of character, were worthless.

Tolstoy's late views – sharply at odds with earlier beliefs he had expressed with equal passion – are the more disturbing for

emanating from the supreme practitioner of the art of fiction. In *What Is Art?* we recognise the ancestor of those doctrines that have fostered a thousand mediocre, state-sponsored novels in totalitarian regimes; the aesthetic that elevated 'tractor realism', in which cardboard cut-out revolutionary heroes struggle bravely and politically correctly against cardboard cut-out counter-revolutionary forces, above Pasternak and Mandelstam. Tolstoy's criterion of greatness in literature would certainly lead to some major re-evaluations: after all, Barbara Cartland's oeuvre is more accessible to the masses and contains more unequivocal examples of goodness and badness than, say, *War and Peace*.

Tolstoy's later convictions about the nature and purpose of art are too readily dismissed as part of the gathering madness of his old age, his descent from Tolstoy the artist of genius to Tolstoy the Tolstoyan. Even so, the belief that literature may be – indeed should be – a positive moral influence is tenacious. The opposite view – embodied in Wilde's assertion that 'there is no such thing as a moral or an immoral book. Books are well written or badly written. That is all' – can still shock even those who are not cultural commissars in totalitarian states.

Some critics claim, hope or imagine that literature may promote *public* morality; that the representations of the artist can deflect human society from a course dictated by greed, tyranny, cruelty, selfishness, vested interest, fear, servitude and the rest; that, by awakening the conscience of the oppressor and helping the oppressed to realise their power, art may hasten the reforms or the revolution that will bring oppression to an end. Others have emphasised the role of literature in promoting *private* morality, through refining our consciousness of others, our sensitivity to them, our ability to imagine into them.

It is not only critics but also artists themselves who believe in, or dream of, a morally useful art. For Keats, true poets are 'those

to whom the miseries of the world / Are misery, and will not let them rest.' And this is a sentiment shared by many contemporary artists. Indeed, Martin Seymour-Smith has identified *Kunstlerschuld* or artist-guilt as the occupational hazard of modern poets and writers who fear that 'literature fulfils no useful, only a selfish function'.

The claims made on behalf of politically engaged art are easily disposed of. History demonstrates that literature is as impotent as music in the face of tyranny and terror. Auden's assertion that 'poetry makes nothing happen' was empirically proved again and again in the twentieth century. The eloquent outrage of great, humane writers has been and is unavailing – quite apart from the fact that a good many major artists have not been on the side of the angels anyway. Where tyrants have fallen, it is difficult to discern the influence of the works and the personal example of those few, immensely courageous artists who opposed the regimes at terrible cost to themselves and their families.

The spectacular collapse of communism in Eastern Europe and the former Soviet Union towards the end of the 1980s is more readily and plausibly understood as a result of economic forces and the inherent instability of all human institutions than as a late effect of the stand of Solzhenitsyn and others in the 1960s and 1970s against the Kremlin, the Politburo and the secret police. A Soviet Union, facing bankruptcy as a result of the arms race and a series of ill-judged military adventures, lost its ability to control the politics outside its borders. It no longer had the strength to crush liberal regimes emerging in its satellites. Once one country had achieved independence, the others saw that their own tyrannical regimes were no longer underwritten from without and that resistance was possible. Artists had only a small part to play in this; as small as the part they have played in the emergence of the new tyrannies, the nationalistic governments of demagogues that are establishing themselves in place of the *anciens régimes*.

One should not be surprised at the political impotence of art. Rigour, scrupulosity, precision, concern for the exact curve of the thing render the artist unfit for the kind of blunt, direct, usually one-sided, invariably simplifying and often dishonest communication that is most effective in political life. Great art does not simplify but makes more complex. The artist's deepest wish *to see things whole* undermines his polemic power: seeing all sides is the true glory of art and its utilitarian weakness. The sphere of public discourse is too shallow for the artist to swim in with his most powerful strokes. In the world of marches, public meetings and newspaper editorials, his is no longer a special, just another, voice. And a rather feeble one at that. You cannot chop down a tree with a scalpel. One editorial in a tabloid newspaper has the opinion-forming clout of a thousand politically committed plays by a talented dramatist.

No work of art can have had an influence on German society and culture approaching that of *Mein Kampf* in the two decades following its publication in 1925. Anyway, the artist has no particular authority or expertise outside the aesthetic sphere – as is illustrated by the terrible misjudgements of passionately committed artists. Pound, Celine, Brecht, Gorky and others of equal stature lent their support, directly or indirectly, to the Great Terrors (though, even as an agent of oppression, as a trophy artist of a totalitarian regime, Brecht – the archetype of the artist *engagé* – was as a reed compared with the Stasi: any power to oppress he had through his work depended upon the power of the Stasi to enforce that oppression). Finally, works of art take time to create and to make their way in the public domain; so art is too late and too slow to intervene decisively in particular, evolving situations.

In short, good art – complex, ironic, self-questioning – is feeble propaganda, just as good propaganda, which tannoys the convenient, transmissible wisdom, is bad art. Which is not to say

that art should not have its political angers: they may flow from the generosity of its vision. But the angers, the generosity, while they add to the work's intrinsic merits, do not give it extrinsic force; they may be accounted part of its internal moral texture, not its external moral power. And that intrinsic virtue may lie as much in form as in content, in the distribution of light and shade, as in what it shows forth in the light.

There may have been a time when art, and in particular literature, was less impotent; a period when mass literacy was novel, and relative political liberalism and the awakening of artists from the hierarchy in which they had occupied a subservient place, created a favourable context in which protest literature would not only be widely read but would also influence the thinking of those who could change things. If there was such a time – a golden age exemplified by Dickens and *Uncle Tom's Cabin* – it has now passed. This may be in part because the mass media have taken over much of the investigative and protest function of arts. The arts have lost those offices, just as they have shed responsibility for conveying practical information – the *Georgics* dimension.

What poem could usefully add to our knowledge of, and our ability to alleviate, the state of chronic atrocity that reigns in Sudan, North Korea or Uzbekistan? When it comes to reporting the world with a view to improving it, to bearing witness that will spur to action, journalism – with its accessible style and its immediate mass diffusion – is infinitely more powerful than any art. To take only one example: the influence of tele-journalism on shaping public perception of the Vietnam War and making it unacceptable to sufficient numbers of the US people was immeasurably greater and more timely than that of the artistic response the war evoked.

Many of those who would concede, however regretfully, the impotence of literature – not to speak of painting, sculpture, music

and dance – to influence the course of public events may still cling to the idea that it has a beneficent moral influence in the *private* sphere. Surely it will inspire better behaviour in ordinary individuals even if it is unable to reform power-mad tyrants, corrupt institutions and those whose vested interests lie in supporting them.

It is possible to imagine many ways in which literature might, with varying degrees of subtlety, conduce to morality: by showing examples of good people (preferably having a better time than bad people); by direct exhortation; by a certain sweet or generous or humorous tone, cajoling the reader to share a tolerant, sympathetic vision of the world, spreading kindness and enlightenment; by exposing corruption, hypocrisy, cruelty, etc. in professions, governments, families, religious institutions, etc.; by taking a long-term view and exemplifying a wide vision and so liberating the reader from the short-term views and implicitly advocating an alternative to the constricted self-centred vision of daily life; by making the case for seeing things *sub specie aeternitatis,* and thereby encouraging tolerance, maturity and humility, liberating the greedy from their greeds, the consumer from the treadmill of getting and spending, etc.

Moral education by examination or exhortation is no longer popular and scarcely lives on even in children's literature. An impressionistic epidemiology of fiction would suggest that literary fiction contains more bad characters than good and that the bad do not necessarily fare worse than the good. Indeed, they may end less stickily. Moreover, in the secular world of most contemporary fiction, the wages of virtue, like those of sin, is death. Perhaps art may have an influence in heightening moral consciousness in a way that is more subtle than that of the sermons, parables and plain tales Tolstoy saw as exemplars in *What Is Art?* Surely by showing us how people are destroyed by others, how they are corrupted, how they

influence one another, do not, say, Henry James's novels increase our sensitivity to others' needs and vulnerabilities and, by enlarging our imaginative grasp of their lives – how they are made and unmade – open us up to deeper, richer, more truly human relationships? Is it not true to say that without the novel and drama, without repeated confrontation with the most skilful representations of, the most precise reflections of, our lives and those whose lives we share, we would be effectively in moral coma? These are views that, in the English language, are particularly associated with the critical tradition of Matthew Arnold, F. R. Leavis and Lionel Trilling.

I am unaware of any empirical data to support these beliefs. The impact on individuals or populations of particular books, or of their cumulative reading experience, would be impossible to study and has not, so far as I know, been studied systematically. Unsystematic observation does not suggest that people who read a lot of good books are more pleasant, less selfish and more willing to contribute to society at large. Those who have to spend much of their lives in the company of the works of the great poets – university teachers of English literature, for example – seem to be at least as nasty and immoral as the rest of us and lack even the redemption of doing a job that directly relates to human suffering.

The idea of a lecturer in English being driven, in response to sympathies induced by repeated readings of *Lyrical Ballads*, to help out in Cardboard City seems implausible. He is more likely to rush to the library to check out the references for his latest piece on Wordsworth's compassion for the common man, making sure he hasn't been scooped by some American with a better resourced library and easier access to computerised bibliographies. And we would protest at the *non sequitur* in this bit of overheard conversation: 'He has listened to so many tender and sensitive piano sonatas by now that he should be fairly tender and sensitive himself.' Few

people who listen to *Fidelio* are prompted thereby to commit even a little of their lives to pressing for prison reforms or to joining the Howard League.

A more typical response is to compare X's staging of 'The Prisoners' Chorus' with Y's, or to speculate whether Z really is up to the role of Florestan any more. Nor would we be likely to accede without question to the suggestion that, as a result of the wider availability of classical music, and the increased duration of exposure of individuals to it, the average moral beauty of the souls in the population will have gone up. (We won't even bother arguing about the trade-off between the intensity and duration of exposure to music.) Nor do we expect those who spend their waking hours saturated in music – conductors, composers, performers – to be better behaved because of it. On the contrary, one is surprised when one comes across a conductor who isn't exceptionally badly behaved. And we are not particularly surprised (though we may be disgusted) when we hear of the Schubertiades in concentration camps and think of the *Gauleiter* enjoying his evenings, after a day's work of orphaning or killing children, listening to cradle songs.

This is fairly obvious. But it is the kind of obvious thing that is forgotten when the arguments get complex or abstract, or when the conversation has been going on – as this one has – for a long time, perhaps two thousand years. What it amounts to is that there is little or no direct evidence for the beneficial moral influence of art; all such claims must therefore be based on *a priori* assumption. There are many reasons for regarding this assumption as intrinsically improbable.

The first is that it is possible to have great art that actually lacks specific referents – for example, purely instrumental music and abstract painting. In the absence of reference, it is difficult to see how an artwork can have either moral or political force. I am

not, of course, suggesting that all great art is non-referential; only that an absence of moral instruction (as is unarguably the case in a string quartet) does not preclude greatness in a work of art. From which it follows that moral force cannot be a necessary condition of greatness in art.

The second, as is brilliantly illustrated by Tolstoy's story, is that the conditions under which one consumes art and the very business of being committed to art either as a consumer or a producer are more likely to subvert than to reinforce moral resolve. In order to pay art the attention it demands and perhaps deserves, we need to be insulated from the distractions of everyday life, including those that come from our suffering fellow humans, such as freezing coachmen. The consumer of art wants above all to be undisturbed – by others' noise, by their cries for help as well as their shouts of merriment – and therefore creates the conditions, either explicitly or structurally (library, theatre, gallery, study), to ensure this. Much notice has been taken of the (necessary) selfishness and unavailability of the artist. The selfishness and unavailability of the art lover who wishes to immerse himself in the great works is no less necessary and may be no less complete but has attracted far less attention. One need not go to the aristocratic lady in furs at the opera to exemplify this selfishness: it is sufficient to consider the absorbed reader's characteristic turned back, his switched-off attention, his Do Not Disturb notice. This is one of the more obvious among the many reasons why, say, reading a book or listening to music is as impotent a means of making us better people as churchgoing. Or why 'those to whom the miseries of the world / Are misery, and will not let them rest' are likely to be unfamiliar with this, or any other, quotation from Keats; why our model of a good person is less likely to be that of a passionate lover of art than a woman who has fostered thirty or more children (and not had a chance to go to the theatre),

the committed local councillor who has not read a literary novel in his life or a caring doctor who has never managed to keep awake through a symphony concert since she was a house officer.

Thirdly, art fosters values that are orthogonal to those of everyday morality (and to describe those values as the basis of a 'deeper' morality is to beg the question); for example, aesthetic values relating to form, and values that transcend the 'merely' utilitarian – the 'merely' assumes that you're not hungry, oppressed or in pain – such as the preservation and celebration of past experience *for its own sake*. Even a didactic painting, if it is any good, will attract more admiration for the way a fold in a fabric is rendered than for the sentiment that is conveyed in it. Art generates secondary values of its own – those of the true connoisseur, of the art snob and of the scholar.

The corruption implicit in such secondary values is illustrated by individuals whose reading prompts them to exhibit their erudition; for example, the writer such as myself who recalls Tolstoy's famous story of the freezing coachman not to learn from it but only in order to pass it on, to use it to support an argument about the relationship between art and morality. It is easy to think up other Tolstoyan and meta-Tolstoyan tales: two connoisseurs competing in the subtlety of their analysis of Allegri's 'delicious' *Miserere*; or an amoral couple discussing the moral impact of 'a wonderful *Dies Irae*' in the crush bar, without a second thought as to whether there will be a real *Dies Irae* and whether it will be as wonderful.

And, finally, the manner in which situations and dilemmas are packaged and presented in art is utterly different from the way in which they are present in everyday life. Life recounted is inescapably different from life as it is lived. Even the soberest and least sentimental story has an operatic element and is a poor preparation for the plinthless actualities of ordinary life, for a world in

which signals are inextricably caught up with noise (at least in part because twenty stories are going on at the same time). Even if the fictional characters are not delineated in black and white, the black print on the white page will still be remote from the much more confused presentations of ordinary reality. (A novel that genuinely replicated the confusion of everyday life – where middles, beginnings and ends of stories are all mixed together and so much is assumed rather than articulated – would be incomprehensible to anyone other than the author.)

It is arguable that extensive reading of great novels may corrupt one's judgement of, and response to, other people. After the brilliantly, or at least clearly, delineated characters on the page, the companions of one's own life may seem drab, inferior and, above all, *ill defined*. It is unlikely that the sentiments we feel for literary characters whose lives we can see as a whole, and from within as well as from without, helpfully educate our emotions for, or train our responses to, real people. Art cultivates our responses to events and situations and people served up in certain ways, profoundly different from those in which they are presented in actual life; by exercising our moral imagination in these quite different ways, it arguably blunts our perception of the moral actualities of everyday life. Events that lack recognisable form may not elicit from the aesthetically trained the emotional response they warrant. In this way the inherent romanticism of most art, its commitment to aesthetic values, is morally corrupting. We feel embarrassment, or even contempt, where we should feel pity or sympathy. The aesthetic sense corrupts our sympathies to a more distanced and distancing pity, and pity to distaste or even contempt.

Anyway, as Whitehead pointed out, the emotions sought through art are largely 'cultivated for their own sake'. If the essence of sentimentality is expressed or felt emotion separated from the

commitment to action, imagined responses divorced from most of the reality in which one would have to act, then art, the contemplation, according to Schopenhauer, of objects uncoupled from the will to act on them, must be quintessentially sentimental. The truth is that art is primarily a spectacle or a reduction of the world to a spectacle. Certainly, representations on the scale and ambition and complexity of novels must develop the detached, spectatorial element in us. Even those novels that are not intended as jewels to be contemplated in abstraction from the world, but lenses through which we see the world more clearly and brightly, are weak moral motors. Tolstoy's expectation that 'the feelings awoken by art would lay in the souls of men the rails along which our actions will naturally pass' seems a pious hope – however great, sincere, moral or earnest the art. After all, the Gospels have been around for a long time, and available to all tyrants for ready reference (indeed, they have been cited by not a few political, and domestic, tyrants).

I have so far assumed that the emotions stimulated by literature are necessarily good or desirable. This may not always be the case. Even identification with characters who have endured injustice or undergone some ordeal may be in some degree masochistic. Fantasies of being subjected to injustice and subsequent vindication (the latter with a completeness possible only in represented worlds) are all-pervasive in literature – in *The Winter's Tale* as much as in rescue operas or Westerns. Such emotions, powerfully evoked by the enhanced clarity of the represented world, may be infantile and corrupting, firing dreams of satisfaction and moral revenge. These dreams are unlikely to be realised in the messy real world: no injustice is ever so completely overturned, no name-clearing ever so absolute, no vindication ever so complete, no revenge ever so sweet, no forgiveness or apology ever so clear-cut, no story-ending so definite.

And there are, of course, other, darker emotional pleasures to be derived from literature. To discover these, it is not necessary to ransack the forbidden shelves where the Marquis de Sade and Leopold Sacher-Masoch peddle their views. One need only consider that, by opening up a reader's consciousness of others and their vulnerabilities, the artist is as likely to corrupt as to make more virtuous. Being more easily able to imagine another's suffering is no guarantee that one will be inclined to reduce it. A novel that appeals to the generous spirit of the kind-hearted may, by enlarging their moral imagination, make the nasty more ingenious and effective in their nastiness.

Referential art is highly unlikely to redirect the spirit from malignity to kindness: the cruel and psychopathic do not necessarily become less so through having their imaginations awoken such that they are able to see things more completely from the other's point of view. This is good only if one's impulses are generous in the first place. The idea that one will read a book generously when one is accustomed to a brutal and mean-spirited and egocentric response to others – when one does not read *them* generously – seems implausible. Likewise, the heightened moral intensity that Leavis, for example, saw resulting from reading, say, the novelists he admired, would be good only if the moral impulses that were thus heightened (and, yes, refined) were themselves good. The moral influence of non-referential art is even more tenuous: Schubertiades in death camps in which starving prisoners played for the pleasure of the guards are only an extreme illustration of the moral nullity of music.

It may be that the moral influence of good art is more indirect than has been considered so far. We may reject the view that simple, didactic 'art' has a powerful effect on practical behaviour; that it can be a direct moral influence. Most critics do. In fact, it could be argued that it is of the essence of the moral force of art that it should

act subtly and indirectly. It appeals to the intelligent and sympathetic imagination – to the human being at the highest level of development: its effects are mediated through reasons and their connections with other reasons, rather than through material causes. Henry James's *The Golden Bowl* is as remote as possible from moral conditioning by praise and blame (or painful and pleasurable stimuli) and for this reason will not be judged by its immediate effects on individual readers or on the world of readers as a whole.

This is a difficult defence. It touches on the fact that the artist's concern with morality is remote from the obvious places where, say, morality impacts on mere survival and comfort, on the symbiotic relationships between individuals that ensure safety and food and warmth. 'Morality' is a huge territory that encompasses all aspects of civility and sensitivity as well as the things that bear directly or indirectly on survival. There are many ways of failing in one's moral duties to others beyond failing to concern oneself with their survival or physical comfort. Art, it might be argued, serves those exotic reaches of a peculiarly civilised morality that touch on the quality of human relationships beyond any merely external function; it is about a mutual awareness that aspires to go beyond respect for contractual obligations, beyond ordinary kindness or even beyond love in the usual sense; it adumbrates a deepening and intensification of relationships that does nothing for peacemaking, for justice or for breadwinning. Art may therefore serve an impractical morality that makes relationships more, not less, difficult, less not more functional – by asserting that there are many ways of falling short morally than denying another the means to physical survival or material comfort.

It may seem perverse to try to rescue art from the obligation to serve practical 'ordinary' morality only to make of it something

more complex that may in fact be ethically dubious. However, I suspect it is nearer the essence of art – which is to enhance human awareness; to italicise that useless thing called human consciousness. We may support this with the reflection that admiring the fineness of moral perception in a novel is more about enjoying the perceptiveness (and perhaps the aphoristic way in which it is expressed, or the brilliance with which the perceptions are realised in the characters and the action) than being moved to a finer morality ourselves. It would be an egregious kind of misreading to regard, say, James's novels as a 'guide to life', just as it would be to read LaRochefoucauld to see how badly people behave and identify the source of their bad behaviour, so that one doesn't fall into the same trap oneself. The 'normal' reading is one which relishes the understanding gained by reading him and enjoys the stylistic perfection of his aphorisms.

A less vulnerable defence would be the suggestion that the moral efficacy of art would be indirect and even delayed. In reply to an interviewer's assertion that 'art can be considered good only as it prompts to action', Robert Frost famously said, 'How soon?' The assumption that art may not have an immediate beneficial effect but may result indirectly in such effects has its ancestor in Shelley's claim that the poets are 'the unacknowledged legislators of the world'. This is fantastical, not only because, as Auden said, it is the secret police who are the unacknowledged legislators of the world – and, in some countries, are the acknowledged legislators of the poets – but because talk of remote effects is necessarily speculative. For once we start thinking about indirect and remote effects, we are into the realm of total uncertainty. Chaos theory, not to speak of Kiekegaard's parable of Socrates and the Ferryman, has taught us that causation in complex dynamical systems – and what system could

be more complex than the interaction between a book, a reader and his world? – is unpredictable and untraceable once one goes beyond a couple of steps in the chain.

The claim for the power of art as a moral influence – that it conduces to better behaviour in private and intervenes decisively for the good in public affairs, improving collective behaviour – seems baseless. The best we can hope for is that art will not make us worse behaved. Is art therefore without value? Should the government cease to sponsor art since it will not make the people better citizens? Should parents discourage their children from reading great literature, since it will not make them kinder in their private lives? Of course not. While art may not make individuals morally better, it will introduce them to a greater selection of the meanings that the world may have, and so widen and deepen their experience of life. Though art is impotent to change the course of history for the better, its image of the terrible and wonderful things that happen in history may in some small sense redeem them, if only for a privileged few: helpless to intervene, it will bear witness, and be true to, the world. Indeed, without taking account of the terrible, art will be empty, trivial; and there may be an element of ordeal in the experience of a great work of art. A masterpiece is a place where many disparate, partial meanings meet and are synthesised into a whole; a utopia of consciousness where much that is scattered or fragmented in life is drawn together.

When he said that a pair of old boots was of more use than the entire works of Shakespeare, and that he would rather be a Russian shoemaker than a Russian Raphael, Pisarev was not condemning art, but clarifying its function. Art is only weakly effective in the utilitarian world of practical need and practical morality. One can think of many ways of making better people (parental influence being the most potent) and of making better states (a free press, for

example, and a democratic tradition of accountability of those in power); great art does not seem to be one of them. It is neither moral nor immoral in the conventional sense: it operates outside the sphere of practical morality, that of the means to survival and to comfort. Its true sphere is to address the final purposes of life rather than the means by which life (and comfort and safety and freedom from want or terror) may be secured.

Although art has only a slight external moral force, it does have an intrinsic morality. This is evident in Tolstoy's own incomparable novels. They illuminate the world with an even and just light, and reach with a generosity of imagination into a vast cast of characters. Only thus can a writer bear witness and respond to his own moral imperative: to present the world as truthfully as lies within his power to do so, notwithstanding the necessary partiality of his vision. He takes the light of common day and makes out of it the substance of a vision; and he traces the light of a 60-watt bulb to the solar brilliance from which it is descended. To do this, he must abjure mean-spiritedness, parochial prejudice and downright nastiness, and be outraged at the outrageous, delight in the delightful (though its deeper reflections may redefine the outrageous and alter our sense of what may afford delight). If his art shows that he is unconscious of the howling injustices and the great issues, then it is unlikely to capture the respect of the passionate and the thoughtful; unlikely to cut metaphysical ice and help us to link the great facts that enclose us – that we are unoccasioned, that we are transient, that we none the less make the world our own thing – with the small facts that detain us. The anger of the artist, unlike that of the journalist, will reach through the remediable and transient to what is permanent and irremediable in the human condition.

Nevertheless, he cannot escape moral judgement: we will not allow him to take us to the higher slopes of human consciousness if

he loses our respect and sympathy on the lower slopes of ordinary morality. An artist who attempts to combine his transcendental visions with anti-Semitism will be rewarded by being remembered not as a visionary but as an anti-Semite. Such is the fate of the Norwegian author and Nobel Prize-winner Knut Hamsun, who may stand for all those who do not subject their art to the severest tests of morality and of generosity of spirit. Mean-spiritedness or immorality below the tree-line cannot be redeemed by large-spirited gestures above the mist. We cannot take seriously, or engage seriously with, a work that is manifestly indifferent to the sufferings of the world, or rejoices in them. A work that exhibits moral beliefs that are utterly at odds with our own cannot, because it will not command our respect, command our attention.

A work of art has not only to be true and beautiful but it must also be good. It does not follow from this that it will promote goodness in those who encounter it, or even those who succumb to it. And the endeavour to 'engage' art politically is based on an exaggerated sense of its power in a sphere not its own. It is absurd to expect that it should make people, institutions or nations behave better; and it is misguided to judge art in terms of its moral intentions or putative moral consequences. Its value – and this is true of fiction as much as of a string quartet, of drama as much as of an abstract painting – lies beyond practical morality. Art and morality are both far too important to be left to each other. If there is such a thing as a literary morality – and I believe that there is – it consists at least in part of devoting the higher attention of one's more inspired moments to coming to grips with the reality that has oneself and others in its grip.

The Experience of the Arts

If art serves no moral function, is it not trivial, empty? Why should it be fostered, sponsored, cherished, taught, encouraged, if it leaves the world morally unchanged? There are two sorts of answers to this question. They are superficially different but underneath probably boil down to the same thing. The emphasis in both cases is on inner effects that do not readily translate into outward manifestations.

The first sort of answer says, yes, the behaviour of those for whom art is important is not conspicuously better than that of individuals who do not read a novel, never mind a classic novel, from one year's end to another, who have never been to a symphony concert and would no more think of going to an art gallery than of abseiling down a hundred-foot cliff. Indeed, the behaviour of the former may, for the reasons I have already dwelt on, be worse. Nevertheless, this lack of outward difference, it is argued, conceals a profound inner difference. Those who have been influenced by art are more reflective in their behaviour; they act consciously, whereas others act unconsciously.

Art-loving humanity, it is claimed, is more remote from unreflective animality or unconscious mechanism. Analogous claims have been made for philosophy and for religious belief – which up the cost of goodness but make it intrinsically more worthwhile. When art-lovers are good, they *choose* to be good rather than merely acting in accordance with their training. Consequently, their good actions, although externally similar to those of individuals without art, are morally of a different order – perhaps because they cost them more than they do the unthinking multitude. To put this another way: influenced by art, we may do the same things but at a higher level and with greater moral investment. The illiterate, loving, foster mother who brings up and loves thirty children does so at less personal detriment to self-development and self-fulfilment than the art-loving mother who is denied by her considerably fewer children uninterrupted access to art galleries for a few years.

This is an implausible, difficult, dangerous and arrogant doctrine which is unlikely to win much support for art. The notion that good behaviour is more admirable in lovers of the arts because it costs them more as they have a soul to look after reminds me of a view once current among middle-class Indians that the poor aren't really poor because they haven't a standard of living to keep up. And it is self-contradictory: it implies that the sensibilities awoken by, addressed in, or cultivated through art make it more difficult to behave decently, that they add to the price of ordinary kindness, everyday sacrifice, etc. Whereas this may reflect the difference between an individual who consciously chooses the moral ingredients in his or her life – including commitment to others – and one who merely tumbles into them (someone for whom, say, child-rearing is a deliberate sacrifice rather than a continuation of a somnambulant existence), it remains purely speculative, and a perfect basis for the special pleading of the selfish. We shall therefore set it aside.

The second sort of answer accepts the irrelevance of art to morality, either in its outward manifestations or its spiritual content, and looks instead to a different sort of inner criterion for measuring the value of art. Art does not make morally better people, or morally better lives, only inwardly richer people, living richer lives. And this is what I propose to discuss here. Much of what I say will be directed against 'the myth' of enrichment but I do not mean to dismiss as mythical all talk of the enriching value of art. I would not deny that life without art would be greatly impoverished – though caution should be exercised in dismissing 'the unexamined life', since the vast majority of lives are lived without art (unless one extends the term to include football and pop music). But I wish to look critically at claims of the kind made by Whitehead:

> Great art is more than a transient refreshment. It is something which adds to the permanent enrichment of the soul's self-attainment.

in the light of Beckett's contrary view:

> At any given moment our total soul, in spite of its rich balance sheet, has only a fictitious value. Its assets are never completely realisable.

Yes, great art is 'more than a transient refreshment'; but is it really something 'which adds to the permanent enrichment of the soul's self-attainment'? Many would like to believe this, without perhaps entirely subscribing to the idea that they possess anything quite like a soul: indeed, it is the master-thought behind the belief that art educates (and that it should therefore be part of the core curriculum), that it has permanent, beneficial, civilising effects that go even deeper than inculcation of the civic virtues. This master-thought

should be inspected in the light of what we know about the actual experience of works of art, and of what we know about the complexity of ordinary consciousness. I shall argue that the myth of enrichment is founded upon an exaggerated sense of the coherence and continuity of our consciousness and its experience of art.

Let us begin with the experience of individual works of art. It is probably true to say that this rarely if ever takes place under entirely satisfactory circumstances. Consider literature. For all but the shortest pieces, our engagement is repeatedly interrupted. There must be few people who have ever read a novel without pause from end to end and fewer still whose reading regularly takes this form. For most of us, reading is a matter of scattered occasions, with large lumps of unrelated life separating the boluses we wolf down. The sense of gathering atmosphere, and our appreciation of the connectedness and organic unity of the work, and of all those other things that figure so largely in critical discourse, are consequently undermined.

The exceptions to the rule that exposure to long works of art is inevitably interrupted are the cinema, concerts of music and the drama in theatre, where continuous attention is demanded and the experience is completed at a sitting. However, for many of us, films, plays and music are most frequently enjoyed at home and are subject to the interruptions that arise from the continuation of ordinary life – the telephone, the shout from downstairs, the shout from within as we recall forgotten tasks. Even where circumstances are ideal for reception, we may not be inwardly prepared: fatigue, preoccupation with other matters, guilt at duties neglected, etc. attenuate our concentration.

There are many other reasons why our receptivity may be less than adequate, aside from physical discomfort and inner and

outer interruption. We may lack sufficient knowledge fully to under-
stand what we are reading, listening to, looking at or watching. Rare
is the occasion when the experience has been preceded by the nec-
essary research to ensure that reception is not marred by avoidable
misunderstanding. Even a modest amount of research – or even
retaining what one has been told as one goes along in a book – seems
to be beyond if not the capacity then the inclination of many. How
often does one hear the complaint that the enjoyment of great Russ-
ian novels has been spoilt by getting muddled over characters with
similar-sounding names?

The very availability of art makes its arrival in our life rather
random; indeed, the most accurate description of our aesthetic life
would be as a series of random bombardments. Books, newspapers,
snatches of music, glimpses of television, fragments of radio, jostle
with one another and with the other events in our lives for mind-
space. Most poems are poor weak things scattered through our lives:
two hours later, they are forgotten, like a post-coital Don Giovanni
mistress. And consider our experience of music. In the imaginary
world of culture, individuals sit down to listen to a piece of music,
having first composed themselves, and remain with it uninterrupted
and in silence from beginning to end. The experience is then com-
pleted and reverberates through the soul, leaving it permanently
moved, enlightened and enriched.

In the real world, we listen to Haydn's Nelson Mass while the
squeaky windscreen wipers are battling with rain adding its own
percussion on the car roof. Afterwards, we try to hum the catchier
bits or oscillate between whistling to ourselves the deeply moving
Amen chorus and making a certain sound with the passage of air
through our teeth. The Mass is preceded by an altercation with a car
park attendant and is succeeded by an unsuccessful attempt to catch

the early evening news. By then the music has been swept away by the return of the outside world with its distractions, indulgences and, above all, its responsibilities.

This particular scenario, likely to be greeted with hypocritical disgust and disbelief by a cultural critic, is not uniquely a feature of the modern era of mass media that use the airwaves to send out a million cultural objects like messages in bottles. Music has always been chucked out into a world at random – though, of course, the randomness is now more obvious as the availability of home delivery has separated it from special occasions, or indeed the specialness of the occasion of music-making. Shakespeare's dramas were played to noisy, disreputable audiences, distracted by the discomfort of worms, cystitis and the unpleasant, obtrusive presence of their neighbours. The ready accessibility of masterpieces of painting through television in art programmes that may be switched off or left on, overheard or ignored through a variety of competing rackets is not all that much greater a step into alienation than the dusty Blake print on the classroom wall representing the Ecstasy of Creation, or the church that is passed every day by the weary peasant whose mind is on other more pressing matters than symbols of a deeper and further reality.

Art has never been protected from what might happen to it when it enters an otherwise engaged human consciousness; and there has never been a time when human consciousness is not already committed or open to being otherwise engaged. Even a professional reader, who may be in a privileged position to be able to read the entirety of a novel uninterrupted (to be properly 'disturbed' by a work of art, *vide infra*, one needs to be undisturbed), has his moments of intermission, his distractions, preoccupations, daydreams, etc.

The context in which artworks are appreciated that I have suggested here seems atypical and even scandalous only by compar-

ison with professional – and hence official – accounts of the experience of art. The professionals (and here I mean mainly critics) have so much invested in their idealised readings, listening, lookings and watchings that it would be too much to expect them to be honest about actual readings, listening, lookings and watchings, or even to recall them. Their readings are not to be trusted but they are worth examining in order to see where myths of the experiences of individual works of art (which must form the basis for the myth of cumulative art experiences and so of enrichment) have come from.

Art criticism may be roughly characterised as falling into four classes: the scholarly (what is being referred to here; who influenced whom; when, why this work was written, etc.); the interpretive (what Smith was trying to say here; what this symbol stood for; what the work really means; what it should mean to Marxists like us, etc.); the technical (the use of key structure; the particular genre to which the work belongs; the type of metre used and how successfully; how the surface tension in the painting is achieved, etc.); and the affective (the emotions this work induced in me, the delight afforded by the conjunction of features A and B, the chilling characterisation of the Ghost, etc.). Most critics will move between these four classes of statement in the course of the valuation of a single work.

There can be little quarrel with scholarly and technical criticism, so long as it serves the work – and hence its audience – and not merely the critic. (Where the one stops and the other begins is a moot point.) The interpretive and the affective, which deal primarily with the critic's own responses, bring us into queasier territory: the (comparatively) objective description of the work passes over into the considerably more subjective account of the critic's own experience. This is queasy not only because there is little objective basis for what is said, but also because it carries an implicit claim about the critic – about his sensibility, his reading, his experience. In short, it 'foregrounds the critic' to an unwelcome degree. The

idealised readings of critics are self-idealising and not infrequently postulate impossible experiences that place the non-professional in an inferior position and encourage him, too, to lie about, or at least misrecall, his experiences.

Consider a relatively mild claim: 'This book is deeply disturbing'. What this probably means is: 'There were times during my reading of this book when I felt anxious/uncomfortable/disturbed.' What it may mean is: 'There were passages in this book where I felt that I should have been anxious/uncomfortable/disturbed.' Why might we be inclined to the latter interpretation? Think of the situation of the critic: he has read many, many thousands of books; he is accustomed to read them in order to formulate a written or spoken response; he has to read them at a certain rate. In other words, the entire context of his reading is that of his own productivity, against the background of his previous endless reading of other books. If we accepted his words literally, replicated in different ways in his reports on endless other readings, we should have to postulate that he is a curious entity in a constant delirium of feelings provoked by books. The truth is that it is somewhere between the job description and the temptation of the interpretive/affective critic to tell a story about a reading that necessarily glosses over the real experience of reading.

Before moving on from the theme of the 'official' (professional) accounts of art experience versus the unofficial (non-professional) unrecounted experiences, I want to make one final, serious point. Many stories of readings (of literature, of painting, of music, etc.) are informed (in both senses of the word) by knowledge – of the artist's antecedents, of his intentions, of his own views about these things. That knowledge feeds into the critic's account of his own response to the work without necessarily feeding into the actual response. He persuades himself that he feels the terror of aerial bom-

bardment – along with the beauty of the composition – when he looks at *Guernica* because he knows that is what the painting is about; he feels the happiness of the newly married Webern in the Cellostücke because he has read the relevant correspondence, etc.

Now, of course, it is entirely appropriate that knowledge should inform response and I am not suggesting that the only authentic critical response is from a position of total ignorance – of the intentions, the antecedents and the autobiographical context of the work. But knowledge brings with it a danger of self-deception, of pretending to oneself that one is experiencing what one is told is there to be experienced. (This is different from the honourable act of responding to an invitation to see if one *can* read/look at/hear a work in a certain way.) The danger is that of confusing one's knowledge of the feelings/experience one should have with the actual feelings/experience one does have.

In summary, critics' accounts of experiences of works of art are not to be trusted, for, as professionals, they have a vested interest in elaborating stories of responses that may bear little or no relationship to their actual responses or to any response possible for a human being. The messy distracted experiences of real readers, listeners, etc. are not, of course, inevitable. Art can command, and of course deserves, better reception. But real readers' 'true stories' are a corrective to critics' self-serving elaborations.

With such examples awaiting any non-professional reader of a book that has so much as a Preface, no wonder the non-professional reader finds it difficult to remember, or to report truthfully to himself, his experiences of reading. The pressure to misremember, or to reproduce (less fluently and compellingly of course than the professionals) the standard stories of reading, which will be rather different from the story given above of the art-experience in a life that is still going on, of art taken on the wing, will be great.

The discrepancy between actual and reported experiences of art may be even greater than I have described here. When people read, watch, listen, etc., it is not always solely for the sake of the works themselves but in pursuit of some vague idea of self-betterment. This may range from the relatively pure motive of the auto-didact to the less pure motive of the individual who reads in order to improve his or her standing, to enhance self-esteem and/or to be able to quote and to show off. There is also the tourist, train-spotting – 'Been there! Done that! Got the tee-shirt' – element: the desire to get a pile of culture under one's belt, which may be linked with the motives just mentioned. Many adolescents pass through a phase of engagement with the arts for these reasons and then keep clear of them for the rest of their lives.

Art may also play a part in the sexual gyrations of youth: it may be, or may seem to be, an important weapon in the battle against the competition. A gift of a CD of classical music or of a volume of poetry may be used to suggest the possibility of a more exciting relationship than the rivals can offer. Art may be exploited to make one sexually more attractive, by suggesting difference, pro-fundity, etc. Exhibitions, poetry readings and events such as the Last Night of the Proms are also means of romanticising relationships and of laying down memories: 'That summer evening when we went to . . .'

Art may be overshadowed by its occasions. The night out at the play may be more important than the play. The time spent queuing for the Last Night of the Proms lasts longer than the time spent under the spell of the music. Attention paid to the actual art may be intermittent: at the very least, it is shared with attention to the occasion itself, to the individual for whom the occasion has been set up. There may only be parts of the event that are sought out: how many Last Night Promenaders have sat through the excruciating

boredom of those *Sea Pictures* in order to join in with *Land of Hope and Glory*?

The Last Night of the Proms is an extreme example but an illustrative one. There are other less obvious, and more unselfish, ways in which art can be subsumed to some purpose alien to it and enjoyed not for itself but used in social interaction. For example, playing through for the sake of another a symphony one knows and loves, consumed with anxiety at the time it is taking to get to the passage one knows and loves, expecting any minute a sigh of impatience. Or re-playing a tune one has heard with delight the day before with a view to cheering up someone else. Or sitting through an Absurd play next to a companion who is bored by its 'silliness', pre-occupied yourself not by the play but by the attitude you should take to your companion's boredom: irritation with his stupidity because the play illuminates the general human condition or acceptance of the companion's boredom (because the play merely reflects the play-wright's rotten life)? A theme, perhaps, for a meta-Absurd play. So many attempts to share the experience of art result in the division of attention between the work and the reaction of the other to the work.

The most significant source of 'lateral interference' in the relationship between art and its consumers is the subordination of art to education. The idea of 'art as education' encompasses not only inner enrichment or development but also externally assessable achievement. The reduction of Shakespeare to texts to be studied for examinations, as a series of tasks to be done, as stuff to be got through, remembered and regurgitated with rote-recalled critical commentaries, is an obvious example. The relationship between an apparent interest in the arts and parental and teacher praise and exam and career success – so that the pupil reads in the context of knowing that he is pleasing – is another equally obvious. But there

are other, deeper absurdities. An experience of my own springs to mind.

Once, crazed by Dinky Toys, I played with them all evening and skipped my homework. As a consequence, I was discovered the following day to be incapable of reciting Macbeth's famous nihilistic outburst on hearing that his wife and co-conspirator had died: the passage beginning 'Tomorrow, and tomorrow, and tomorrow . . .' My punishment was to spend a drowsy summer evening clapped in detention, a crestfallen delinquent, rightfully convicted of being unable to recall how life (my life, my teacher's life, my parents' lives, presumably) is/was

> . . . a tale
> Told by an idiot, full of sound and fury,
> Signifying nothing.

Fancy forgetting that! Allowing it to slip one's mind that life is utterly futile! The appropriateness of the punishment was remarkable: what better reminder of the inanity of life than being kept indoors on a crickety summer evening, and so being denied the longed-for-futilities of bat and ball? The penalty was as well earned as that suffered by the man in the nursery rhyme who wouldn't say his prayers and was seized by the left leg and thrown down the stairs. (A fractured neck or femur concentrates the mind wonderfully upon the Ultimate Other and focuses one's thoughts on the Empyrean where He dwells.)

I have so far concentrated on the experiences of single works. Our ultimate concern, however, is with the postulated cumulative impact of art upon the inner self, and the notion of progressive enrichment. As a transition to this question of the 'adding up' of works of art, it is worth dwelling for a short while upon the after-life

of artworks, their reverberation in the consciousness after we have laid the book down, left the symphony hall, looked away from the painting. At first, this does not seem very encouraging: what we remember of a novel – even one that has gripped our attention – is often very patchy; the echoes of the music often take the form of inaccurately recalled (or even worse, whistled over) fragments of 'the main tune'; and our mental image of a painting we have just looked at is considerably more impressionistic and rather less impressive than the original. Art objects seem to live on in our minds as grotesque reductions or even parodies.

Things, however, may not be as bad as the phenomenology of recall would suggest: think how differently we re-read a novel as opposed to reading it for the first time; and how different a second or third listening to a symphony is from a first. This implies that we have retained much more than explicit recall would indicate; that a tremendous amount of implicit memory has been laid down, so that second time around we know where we are going and have a sense of pattern in the work which we did not have before.

Even so, the life of the work in our mind is more complex and problematic than the simple stories of critics would have us believe. Even a single reading of a novel, in which the 'organic unity' of the whole is set before us, assumes retentive powers that we do not seem typically to possess. Our backward glance does not take in the entire landscape that has been set out before us. And successive readings, or listening, or lookings, while they may deepen our experience of the work, if only by making it easier for us to grasp it as a whole, may also confuse and muddy our picture. For different encounters will take place in different moods and be driven by variable intensities of commitment. A deeply absorbed reading of a novel may be succeeded by an interrupted, bad-tempered re-reading. A piece of music may move us deeply on one listening and mean nothing on

another. How will those two – and many other – different readings interact in the mind of an individual who is not a professional elaborating a master-reading that takes the best out of each of the individual readings?

Enough about the single work. 'Progressive enrichment' encompasses more than the experience or the effects of a single work – though the latter must be its foundation. 'Enrichment' is supposed to be the summed effect of the experiences of many works: of novels piled on to novels, of short stories on to sonnets, of paintings added on to symphonies, of sculptures to essays, and so on. This notion of progressive enrichment is especially tenacious in relation to litera-ture. There is the idea that, for example, one's literary experience *builds up* – as if it were, in some sense, all present at once, adding up like leaves forming humus or photosynthesis ultimately growing a trunk. At the very lowest level, there is the idea of being 'well read' and of 'the well-stocked mind', of a living store that is added to over years. In the light of the doubts expressed as to whether even a single work could add up to its totality in the mind – to the unity set out by the critic in his professional, written-down response – this con-ception of the cumulative impact of the things one has read over years adding up will seem extremely dubious indeed. And the addi-tion across the different arts, with disparate experiences converging to an enrichment of soul, will seem yet more dubious.

First, and most importantly, the notion of enrichment is based upon a conception of the mind as a receptacle gradually filling up. Much modern psychology, insofar as it has an overall theory of the mind (as opposed to behaviour, propensities or cognitive processes) would see the mind as more of a conduit than a bucket: that much of what passes into one's mind passes through it rather than adding to its assets. Whether or not one accepts that psychol-ogy has anything to tell us about mind working at this level, it is easy

to see how the 'increasing richness' idea is based upon the mind as a definite thing – an idea which no longer commands general assent and which is difficult to make coherent, even less find evidence for. It is perhaps, as we shall discuss presently, a hangover from religious ideas about 'the soul'. (This is not of course to deny the effect of repeated exposure and active engagement in increasing the ability to understand and enjoy complex works.)

At the very best, one seems with works of art to reach a kind of dynamic equilibrium after a while: new experiences and new knowledge are accommodated at the cost of creating new amnesia – so there is no 'progressive enrichment', only, at best, a steady state, with the mind 'holding its own'. This objection may provoke the counter-objections that it is itself wedded to a literal-minded view of the mind as a fixed storage capacity device, rather like a hard disk – or, to use a more homely analogy, to the very 'bucket' theory of mind dismissed a moment ago. Moreover, it assumes that enrichment is about accumulation of knowledge, or something like it, when it could be argued that enrichment is about assimilation of knowledge, its transformation into 'the tissues of the imagination', its shaping or informing of a world picture. But, in a way, the dynamic equilibrium account of 'progressive enrichment' is the best that can be made of the bucket notion. So it follows, therefore, that, if even this version is unacceptable, then 'progressive enrichment' has to be made sense of in some other way but no alternative interpretation seems to be forthcoming.

There are certainly many unanswered questions – such as, for example, how the elements actually add up. How do Ezra Pound, Sir Thomas Browne, Homer, Kant and Leopardi converge within the cultivated individual? And how do they sum with symphonies, paintings, an evening at the ballet, etc.? Are they like snowflakes adding to a snowdrift, there being a point (or a level of the mind) at

which each loses its own identity? In what sense are they then still individually available? How are they present to one in ordinary, extra-aesthetic life? Are they all present at once? In a trivial, partial sense they might be, inasmuch as elements can be retrieved from all of them in response to the appropriate stimulus, that is to say, the appropriate accident. Most commonly, they live on in the form of fragments, passages, things-to-say that come to mind, flashes of recall, prompted by the contingencies of experience. It might be argued that, insofar as they *are* separately retrievable, and so retain their distinct after-life in our memories, they are not fully assimilated into a *Weltanschauung*, a soul-tone, an informed outlook; that it is the wrong result for prolonged immersion in the great literature of the world to lead to, say, a mind stocked with separate retrievables. Certainly, a well-stocked mind is not always a desirable characteristic: the cultured individual, who invariably has a quotation to fit an occasion, can easily modulate into the literary bore we all dread.

We have no model, then, for progressive enrichment. At any rate, it doesn't seem as if, say, a lifetime's reading experience adds up to some kind of literary super-experience. Which is hardly to be marvelled at if not even the reading of a single book has an unbroken wholeness, nothing at any rate corresponding to the 'organic unity' the critic unpacks or constructs in his report on an ideal, professional reading. Or consider our experience of music. Each piece is a separate event and, although we may grow in knowledge or connoisseurship, it is difficult to see the sense in which we are richer after a hundred symphonies than we are after ten. Our first encounter with great music in adolescence is at least as intense and rewarding as subsequent experiences. We may return to Brahms's chamber music again and again for ever-different experiences, but it is doubtful whether it makes sense to speak of those experiences as increasingly rewarding.

Of course, we have no satisfactory model for *any* aspects of the self, nothing to help us to understand the relationship between the current account of experience and the deposit account of standing structure or stable propensity – between, let us say, sensation and character. But the progressive enrichment idea *assumes* a certain model of the mind, of consciousness – one, moreover, that draws from two conflicting traditions: the religious tradition with a stable soul; and the secular tradition of a self that is transformed through experience.

The most important criticism of the idea of progressive enrichment is that it is untrue to the moment-to-moment reality of consciousness. As Paul Valéry pointed out, 'If the life of the mind could be recorded as a continuity, it would be a revelation of *total* disorder and incoherence.' This is the message repeated by a thousand modern novels. Think of the interior monologues in James Joyce's *Ulysses*: do they not reveal the mind, its beliefs, its knowledge, its convictions, as a colloid of self-mutters, random recollections, images, associations, etc.? (It is a special irony that those who believe in the notion of 'progressive enrichment' through the experience of art are often those who take seriously contemporary art – which is frequently characterised by questioning the concept of a stable self, of a steady viewpoint, a person-object.) Even among those who resist the fashionable idea of an exploded, fragmented self, few would dissent from Beckett's observation that 'at any given moment our total soul, in spite of its rich balance sheet, has only a fictitious value. Its assets are never completely realisable.'

There is another way in which the idea of 'progressive enrichment' is unsatisfactory: it commits one to postulating a process that is (a) intrinsically endless, and so (b) inevitably brought to a halt at some arbitrary time. Since it emphasises not the experience, the current account of consciousness, but the cumulative effects of such

experience, in the deposit account of an ever-enriched conscious-
ness, the purpose of art is referred to as a journey that is not only
always unfinished but one that has no clear model of being finished.
There looms the rather dispiriting idea of a project that is doomed
to failure and, indeed, replicates without modification the wider
tragedy of life.

The notion of 'progressive inner enrichment' as the goal and
purpose of art ties it into a journey. The idea of a journey is so attrac-
tive because it borrows glory from the idea of a spiritual journey, a
pilgrimage towards something like the revelation of God and of
one's relationship to Him. The notion of a large vector that goes
through and connects the seemingly scalar moments of life trades
on ancestral religious sentiments about the purpose of life. And this
is a reminder of the source of much of the 'seriousness' and 'impor-
tance' of art: where the practical uselessness of art is recognised, the
transcendental, trans-utilitarian values of religion are gratefully
expropriated.

To seek the purpose, the significance, the justification of art
in something corresponding to inner enrichment, then, seems likely
to be as unconvincing as seeking these things in the putative moral
influence of art. Our experience of individual works does not
add up to the kind of whole that the critic postulates in his self-
documented experiences, his idealised reports of encounters that
have taken place in ideal circumstances. These are idealised beyond
plausibility, being untrue to the psychology of human consciousness
and tending to confuse the standing structures that can be observed
objectively in the work with the evanescent experiences that it trans-
lates to in the mind. They are not only at odds with psychology but
take no account of the conditions of daily life under which art is
consumed. Art may create its special places – of the soul and the
imagination – but it has to pitch its bivouac in the chaotic littleness
of everyday life. There is no permanent, privileged place in the soul

for its places; the return from the ecstatic pleasures of the opera to the theatre cloakroom and the wet rain outside is both abrupt and inevitable, as Hanno Buddenbrooks found after he had seen *Lohengrin*:

> And then the dream became reality. It came over him with all its enchantment and consecration, all its secret revelations and tremors, its sudden inner emotion, its extravagant, unquenchable intoxication . . . The sweet, exalted splendour of the music had borne him away upon its wings.
>
> The end had come at length. The singing, shimmering joy was quenched and silent. He had found himself back home in his room, with a burning head and a consciousness that only a few hours of sleep, there in his bed, separated him from dull, everyday existence.

The artist here is more honest about the place of art in real life than any critic would dare to be, recognising that the artistic experience is always broken off, or interrupted, or divided. It is always multiple. It is inescapably in addition to everything else; it must therefore add to, as well as heal, our dividedness. It cannot be part of a convergence over time towards a kind of unified self whose multiplicity is the surface of a deeper unity. Attractive though that idea is, it seems unlikely that art *does* restore to us a lost unity, that we are unified in art – as creators or consumers – to a degree that we are not elsewhere. It is not thus that art reveals to us a destiny, a destination, of our individual consciousnesses that is otherwise hidden from us; not in this wise are we made whole and purposeful through art.

The idea that the point of art is to bring about permanent, progressive changes in the self or soul is therefore deeply vulnerable. Summation across episodic experiences of art to produce a grand

total that is reflected in a changed structure and modified tissues of the inner self presupposes a strained and implausible conception of the self and of the mind. It seems profoundly untrue to what we know about the variousness, complexity, incontinence and essential infidelity of human consciousness – something that many artists and critics (when they are not defending their own interests along with the myth of enrichment) have acknowledged. Like most aesthetic theories, it assumes that the consciousness of both the producer and consumer of artworks is considerably more unified than they are. It also ties the function of art into a project that is both unfinished and interminable – and this is a recipe for despair.

*

This must not be taken to imply that art does not extend one's experience, widen one's sympathies and permit one to imagine into the lives and even the consciousnesses of others. Of course it does. But this must be distinguished from the obligation to inform or to instruct. Novels may be about distant places, distant times and people who are, to 'us' (whoever we are), remote but their primary aim is not to transmit information about those distant places and times and those remote peoples. Otherwise the duties of art would be unending – or limited rather arbitrarily. If the purpose of art is to inform us of what it was/is like in other parts of the world at different times and for different sorts and conditions of people, then it is going to have to cover thirteenth-century Hanseatic merchants, cocaine barons in twentieth-century South America, enslaved Helot women in Sparta, professional boxers in China, neonates with poorly controlled epilepsy in prehistoric Iceland, etc., etc. There would be no end, or only an arbitrary end, to the art-assisted exploration of the human neck of the space-time continuum.

Certainly art will invite us to share in the experiences of others and so encourage us to recognise the equal reality of individuals we may have been inclined to see only as background to our world and preoccupations. This will, however, still depend at least in part upon a more literal sort of recognition: experiences by proxy become a way of pouring the wine of one's experience into the new bottles of another, remote individual. The more remote the character, the setting, the situation, however, the lower the ratio of inwardly illuminated, imagined reality to fact (or fiction) one can digest in the sense of imaginatively reconstructing. With the nearer to hand, the ratio will be higher and the calls on one's own experience will be greater: the template of the representation will be more receptive to one's experience. The presentation of a contemporary character from one's own culture will be to a much greater extent an invitation to *recall*, to explicit recognition of what one had only implicitly seen or had allowed to go by without full registration. Even the sense of the alien, of Dark Forces, will draw upon childhood terrors, early fears of The Dark, and from other homely but profound sources of imaginative energy. Our encounter with the Other is transformed from blank collision to interaction in proportion as we are able to summon ourselves to pour into it.

There may seem to be a tension here between the connectivity of the work of art and the connectivity we demand in the experience that will correspond to the large idea expressed in it: the former is a connectivity in an object outside of us; the latter a connectivity within us. This is particularly evident when we read fiction. If the purpose of reading a story set in Cornwall were to perfect our own experience of Cornwall, then the logic of the story would be at odds with the logic of perfected recollection: the particular events recounted in the story would have nothing to do with our experience. This apparent difficulty arises out of a misunderstanding: the

144 SUMMERS OF DISCONTENT

perfecting of experience in art is not the perfecting of the experiences that we have actually had. If this were the case, we should all have to be provided with our own customised works of art; indeed, we should have to make our own. What we are offered is a virtual experience which, on account of the form which makes a unity out of multiplicity and variety, corresponds to the larger ideas, while remaining rooted in the particular – either a specific sensation (as in music and abstract painting) or a specific referent (as in literature). Where the materials out of which the work is made are referential (as opposed to purely sensory experiences), their referents will need to overlap with our own experience (by coinciding with or containing common elements) or be sufficiently universal as to correspond to the potential experiences of 'anyone' (within certain cultural limits).

The concern just raised, however, opens on to an important source of complexity – and of confusion – arising out of the different relations that the artist on the one hand and the audience on the other have to the work of art. The world the artist writes about or paints will differ to a greater or lesser extent from that of his audience. For this, and for other reasons, it would surely be surprising if, for example, a play meant the same thing to, or served the same purpose for, the individual who wrote it, the actor who played the lead role night after night, and the member of the audience who saw it once. The question this raises is dealt with in the next chapter but it cannot be ignored entirely in an essay that approaches art from the viewpoint of the individual's need for the perfection of experience.

The Creation of the Arts

We've considered art from the viewpoint of the audience. Now let us look at art from the viewpoint of the artist. Consider those crucial passages in *Remembrance of Things Past* where Proust connects his discovery of the miraculous power and sweetness of involuntary memory with the genesis of his art and, indeed, of the very novel in which the discovery is reported. For him, involuntary memory united a present sense impression and a past – and so idealised – world of memory. By this means 'that ineluctable law which ordains that we can imagine only what is absent' was 'temporarily annulled'. But the intensive manifold of past and present belongs to neither the past nor the present, and so is extra-temporal. Nevertheless, it belongs to the self, whose extra-temporal nature is also therefore revealed. The revelation of this extra-temporal being explained

> why it was that my anxiety on the subject of my death had ceased at the moment which I had unconsciously recognised the taste of the little madeleine, since the being which at that moment I had been was an extra-

temporal being and therefore unalarmed by the vicissitudes of the future. *Proust, À la Recherche du Temps Perdu, translated by C. K. Scott-Moncrieff, revised by Terence Kilmartin (London, 1981), p. 904*

Involuntary memory brought with it a feeling of being safe: whatever happened to him in time, it could not touch his essential (extra-temporal) self. Even so, his life's task – that of recovering and preserving the past in a work of art – was not superfluous. On the contrary, involuntary memory showed the way towards achieving that project:

> This [extra-temporal] being had only come to me, only manifested itself outside of activity and immediate enjoyment, on those rare occasions when the miracle of analogy had made me escape from the present. And only this being had the power to perform that task which had always defeated the efforts of my memory and intellect, the power to make me rediscover days that were long past, the Time that was Lost. *Ibid., p. 904*

Involuntary memory, providing both model and material, showed the way to his book, rather than replacing it:

> it was time to begin if I wished to attain to what I had sometimes perceived in the course of my life, in brief lightning flashes, on the Guermantes way and in my drives in the carriage of Mme de Villeparisis, at those moments of perception which made me think that life was worth living. How much more worth living did it appear to me now, now that I seemed to see that this life that we live in half-darkness can be illumined, this life that at every moment we can distort can be restored

to its true pristine shape, that a life, in short, can be realised within the confines of a book! *Ibid., p. 1088*

Tout, au monde, existe pour aboutir à un livre. Art would capture, and so confer permanence upon, the world as illuminated by the privileged light of involuntary memory. By this means, the world that had possessed the artist would itself fall into the artist's possession. Indeed, the book, by outliving the artist, would ensure the survival of the remembered world beyond the artist's own life. Bergotte is dead but lives on through his books:

> They buried him, but all through that night of mourning, in the lighted shop windows, his books, arranged three by three, kept vigil like angels with outspread wings and seemed, for him who was no more, the symbols of his resurrection. *Ibid., p.186*

The finished work is a kind of safe deposit for the author's consciousness, developing the larger, inchoate forms of daily life and, by embodying them in a stable or repeatable object, preserving them. It might be expected that the (private) *self*-preserving, *self*-expressive function of art should dominate over its (public) *world*-preserving, *world*-expressive aspect, if it is to ensure resurrection of the artist rather than mere immortality attached to a name that has lost its body. However, these two aspects are not clearly separate, as Jorge Luis Borges has expressed beautifully:

> Through the years, a man peoples a space with images of provinces, kingdoms, mountains, bays, ships, islands, fishes, rooms, tools, stairs, horses and people. Shortly before his death, he discovers that the patient labyrinth of lines traces the image of his own face.

The artist builds to seize the initiative from time and hence to palliate the sense of being helplessly swept to old age and death. At the very least, the process of building, howsoever difficult, frustrating, even agonising, is a distraction from death; the artist's ambition may be death-inspired, the materials may reach into the death-stalked depths of life, but the protracted struggle with memory, articulation and organisation is a powerful antidote to the terrifying thoughts that assail the reflective mind when consciousness is not pre-empted or opacified by making and mending. Not only the completed building but the process of building counters the anguish of being incontinent of moments, of being hurried through a landscape one cannot clearly see, on the way to a landscapeless blank. The act of building conceals the abyss more completely than the building does, though this remains journeying, not arrival.

In short, there is a double 'salvation through art', arising from the process of the creation and from the finished work. But wait: who is saved? Do not all the benefits accrue to the artist and not the recipient, especially where the art in question is literature: preservation of the past in a perfected form; distraction from the sense of loss and attrition and impending dissolution by building a monument to one's own life and so serving the comforting myth of one's posthumous existence; rescuing a deposit account of an oeuvre from a current account of loss? Yet without the reader the writer's project would be empty: his own future self would not be enough to give his project meaning. So how relevant are the needs and motives of the artist to the function of art?

The danger of paying too much attention to these things in judging works of art – and in judging something to be a work of art – is vividly illustrated by the critical habit of relating the work to the psyche of the artist (a trend whose worst manifestation is the

psychoanalysis of artworks) and that parallel nonsense that talks about 'art as therapy'. In its most pernicious and dispiriting forms, the latter moves from the claim that we all have neuroses that would benefit from the therapeutic effects of self-expression, via the claim that we are all 'creative', to the assertion that we are all artists and that the artefacts that result from our neuroses are works of art.

Art as therapy confuses the benefit to the producer from engaging in more or less artistic self-expression with the value of the product to others. The fact that it did you a power of good to clear out your bowels does not enhance the value of that product to anyone else; it certainly does not make it any more attractive. Likewise, the reader or listener should not be expected to be concerned about whether making the work of art comforted the artist. Equally irrelevant is the question of whether the work came from the 'depths' of the artist: what matters is whether it reaches the depths of the individual reading, looking at or listening to it. In a sense it is others who determine the depth of the work, just as it is others who determine the objective value of one's thoughts.

From the point of view of the audience, it is not the neurosis (or even the metaphysical hunger) that drives a man to write or paint that matters so much as the talent. The two may not go together: there is no reason why a heightened sense of our incontinence of time and of the death towards which we are helplessly swept without ever being properly or fully *there*, in our lives, should co-exist with whatever it is that makes for a sense of musical structure or fluency with a pencil. There will be many who have the metaphysical drive to create art without the necessary talent; others who have the talent without the metaphysical drive. For great art, both are necessary.

In saying this, I am trying to avoid the absurdities – and chat-show tedium – that results from approaching the work of art solely from the perspective of the artist, from the standpoint of his or her

needs. Why the individual artist is driven to create is surely of limited relevance to the meaning of art for the audience and so to the meaning of the work. There will, however, be important areas of overlap. First, the reader or listener has, in order fully to partake of the work of art, to recreate it, to re-produce it, in himself. The reader alive to the full meaning of a novel participates in the act of creating it; the listener of the music constructs, as well as discovers, its form in himself. Secondly, the world invoked in literary art is a shared world. The elements and some of the major patterns will be common to the writer and his readers. When he perfects his experience of his world, when he preserves that world, in his works, he is perfecting our experience of our own world, saving *our* world from extinction. In other words, the author's perfection of his experiences offers us a way of perfecting our own similar experiences – or, by contrast, our dissimilar ones. When I read Proust, his perfected past is the perfecting of my past.

This must not be taken, however, to suggest that a novel – or any referential or representational form – is a device for triggering daydreams, for turning us inward on ourselves. If this were the case, there would be a constant tension between the direction of the work of art and the organisation (or disorganisation) of our memories. We would be constantly 'drifting off', like inattentive schoolchildren dreaming of escape from the classroom, and would not have that cumulative interaction with the work that would reveal the form to us and enable us to participate in it. No, Proust's prose mobilises elements of our past to fill his shapes that will add up to the great shape of his novel. Of course there will be much in his novel that will not correspond to anything in my own experience but there will be sufficient overlap to seduce me into pouring myself into a realisation of the work in a reading.

Where there is no coincidence of experience between writer and reader, there can be no reading, only incomprehension. In the

case of (non-referential) music, the perfection of the present moment through the union of form and the instant of content does not require sharing of experiences – except perhaps of experiences of the musical form in question. In either case, the formal structure that brings so much of the variety of the world together into a portable mindful will liberate me to delighted contemplation of my own world.

My argument is that there is sufficient overlap of the situation and the role of the artist and audience to give face validity to a theory of art that encompasses them both. Nevertheless, it is possible to develop a totally different – somewhat more pessimistic – view and suggest that the essential audience of artists is composed of other artists, just as philosophers speak largely to other philosophers and mathematicians to other mathematicians. This is worth exploring, if only as a corrective to the sentimental counterfactual claims that 'art has universal appeal', speaking, as Coleridge said of Shakespeare, 'for all men, in all places, at all times'.

Let us take seriously the idea that the artist is driven by a metaphysical hunger, by an unremitting hunger for completion of the sense of the world in a perfected experience that will answer to the universal need – not otherwise met in everyday life – fully to be there. Such a drive does not seem exactly pandemic in the human race; few seem haunted by an insufficiency of meaning; or not at any rate very often. And when they are, they do not recognise it as such. Appetites and their satisfaction or frustration, hopes and ambitions, fears and griefs, ordinary gossipy interest in things, satisfy most individuals' need for meaning and give them a sufficient sense of being there; moreover, they have strategies for dealing with them, if troubling gaps do open in their busy lives.

Those who share the postulated metaphysical hunger of the artist are therefore in the minority. Now consider the more specific claim that art is to take on, or has taken on, the mantle of religion;

that it is an attempt to create meaning or meanings as great as those which were once carried by the Word of God – or, at least, by the word 'God' – experiences as solid as the terrors and ecstasies of the true believers. A truly serious artist in a post-religious society will be engaged in creating something that will fill the great hole in meaning left by the departure of God. This, too, is clearly not a preoccupation of the majority – or there is little sign that it is.

It may be that in a secular society, that single great hole in meaning – which cohered through the idea of a God beyond the reach of our knowledge and imagination – no longer exists but has been diffused into a thousand insufficiencies; so that it becomes an additional preoccupation, or secondary function, of the artist to restore the gap in sense that has been scattered into individual occasions. Now that the 'distant, difficult' God is no longer there to be a focus for our sense of the incompleteness of sense, the artist's function is to bring all the insufficiencies of experience together into one great emptiness, not only to respond to the metaphysical hunger but to cultivate it and keep it alive as a driving force.

Whether or not this is the case, the salvation the artist seeks through art is not needed by most of his audience. But if they do not share his hunger (or his hunger for a more permanent and more ultimate hunger than his cycling appetites, for a more permanent preoccupation than the small change of his projects), how is it that art commands such large audiences? An obvious analogical question springs to mind: how, if so few people were prone to visions of God or could be described as in any continuous sense spiritual, were the churches so full and so many individuals involved in churchly activities? The answer may be similar in the two cases.

The Church was a major centre of power. Conformity to the demands of the Church was necessary for survival and, for some, was a source of livelihood, authority, power and glory. Art, too, is a

social institution and involvement with it may bring a livelihood and a certain amount of social cachet. And for schoolchildren and some university students simulating an interest in and engagement with the arts is necessary for success, even survival. Art supports arts administrators, educators, academics, journalists, impresarios, entrepreneurs and, not the least numerous of these, non-artists embarked on careers as artists.

Surely art cannot owe its prominence and prestige simply to a huge, groundless prejudice in its favour reinforced by educators, self-improvers, auto-didacts, the honestly deceived who try art for a while before admitting defeat and returning to less taxing recreations, by the snobs and show-offs attracted by the mystique or social cachet carried by the idea of art and by the vast numbers who earn their living directly or indirectly through it? All prejudices, after all, have some original basis. The basis for the prejudice in favour of art is the fact that the meanings artists play with and try to perfect in their art are borrowed from everyday life.

Consider Balzac. Supposing we imagine him trying to fill the terrible emptiness of his life, to deal with his sense of not being quite there, by possessing the entire world and bringing it together under the great form and idea of his *La Comédie Humaine*. The meanings he uses, the experiences he incorporates into his novel, are ordinary human meanings and experiences revolving round ordinary human appetites – sex, greed, cruelty, ambition. His creative drive may come from a desire to surpass them all; but they are the substrate upon which it operates, the material through which the great forms are revealed. His audience need not share his hunger or his vision but may feed upon the food his emptiness consumed in its attempt to satisfy a greater hunger than experience could meet. His readers are not obliged either to consume as a whole the work that answered to Balzac's hunger for an overview of his world, for a culminating

vision, his totalising drive to possess the entirety of the reality that so possessed him. They may find an inattentive plot-following sufficient to their own needs. If a novel participates in both metaphysics and gossip, one may read it once for the gossip – who did what to whom – and one is not obliged to re-read it to satisfy the metaphysical hungers that may have motivated the artist.

Great art, in short, is entertaining. Most of those who consume it will do so for the sake of the entertainment it affords (as well as for all the other secondary reasons, hinted at above, that people choose acknowledged great art rather than the popular music, fiction, painting, etc. of the day: curiosity, desire for self-development and education, snobbery, desire to have read, to have possessed, visited, toured, to win approval, to impress, etc.). Until recently, secular artists have *had* to be entertaining in order to earn their living and get a hearing. Great artists have always had the option to be mere entertainers; that they have chosen to be more than this has often (but not always) been at the cost of success.

Beethoven could have written any number of more acceptable pieces than those he wrote; there was no need for him to make life more difficult for himself by composing the mighty works – the Ninth Symphony, the *Missa Solemnis*, the late quartets and piano sonatas – that he produced at the end of his life. He could have poured out quantities of best-selling *tafelmusik*. Only his desire to take things to the limit, to create massive forms that would constitute a new world equal to the one that had him in its grip, only his metaphysical hunger made these works the agonising and self-destructive necessity they were. Kierkegaard's description of the poet as 'a man who pours out the agony of his soul but whose lips are so fashioned that he produces ravishing music' seems absurdly, almost embarrassingly romantic and self-romanticising, but does capture the distance between the artist and audience, between the

writer driven to write by a metaphysical hunger and the ordinary reader, reading to kill time, entertained by his works.

I exaggerate the gulf that may lie between the artist and his audience. But if one is going to make, as I have, strong claims for the deep origins of art, while at the same time presenting the reality of consumption, it is difficult not to think sometimes of the audience of non-artists as an innocent party caught in the cross-fire between artists, or of artists talking to themselves. The ratio of those who feel the hunger which art can satisfy to those who engage with art in some way or another is probably about the same as the ratio of mystics to church-goers.

Such a view of art may impress as merely élitist. And so it is, inasmuch as it maintains that the essential purpose of art is to meet a need felt continuously and deeply only by a few, and that most of those few will be artists (or perhaps philosophers and occasionally scientists) themselves. Insofar as art has wide appeal, it does so in virtue of other things than its answering to a metaphysical need. But it is not élitist in the negative, exclusive sense of the term. The metaphysical hunger to which art answers is universal, but in the vast majority of human beings it is overshadowed by more brutal hungers, more searing preoccupations. Historically, where that hunger has not been extinguished by more basic ones, it has been appropriated by religion which brings in its train many non-metaphysical pre-occupations – of doctrine and denomination, of power, of morality, of group identity and other modes of social conformity – that have all but cancelled the metaphysical element and discredit religion in the eyes of freethinkers.

Now, in a secular age, there is much that can be found to suppress, or pre-empt our metaphysical preoccupations. Our camcorder moments are but one of many manifestations of our avoidance of the metaphysical obligation opened up by the mysterious

unoccasioned gift of human consciousness. No one, however, is forbidden to participate in the great adventure of art. Along with science, it is the major force for changing the outlook of humanity and reforming humankind's self-image. While most do not feel the need for the salvation offered through art, art (and science) create the future of human consciousness in their long and ultimately meaningless but no less glorious journeys into newer and deeper and richer meanings. The visionaries change the world in which the non-visionaries of the future will live.

*

Art is part of human life and, as the conditions, the preoccupations and contents of human life change with technological, political, intellectual, spiritual and other revolutions, so too will the nature and purpose or purposes of art. The immediately preceding discussion of the complex questions surrounding the different relationships of producer and recipient to the work of art should alone be sufficient to condemn any brief account of *the* function of art as an almost laughable simplification. Nevertheless, I stand by its basic premise: that the function of art at the present time is to be found not in any useful purpose – in education, in a social mission to reform the private and public morality of mankind, etc. Art does something different: it addresses the famous question in Mill's *Autobiography*:

> In this frame of mind it occurred to me to put the question directly to myself: 'Suppose that all your objects in life were realised; that all the changes in institutions and opinions which you are looking forward to, could be completely effected at this very instant: would this be

a great joy and happiness to you?' And an irrepressible self-consciousness distinctly answered: 'No!' At this my heart sank within me: the whole foundation on which my life was constructed fell down. All my happiness was to have been found in the continual pursuit of this end. The end had ceased to charm, and how could there ever again be any interest in the means? I seemed to have nothing left to live for.

Since there will never be a time when all that needs to be done has been done, the preoccupation of the artist will always be premature: art presupposes that material needs can be forgotten or shelved for a while, and answers the emptiness that threatens to haunt us whenever experience is sought for its own sake. The very existence of art and mankind's preoccupation with it, therefore, is a scandal.

I am also conscious that, in determining the place of art in life, I have, as I have said, tended to talk up art and to talk down life. (This is an occupational hazard of aesthetic theorists.) Nevertheless, I still feel that my position is sufficiently robust to perform the job marked out for it. For the point of my thesis is to protect or liberate art from theories that would subordinate it to some other, non-artistic purpose; to suggest that art, like consciousness, is *sui generis* and so cannot be reduced to a function, least of all to some useful function. If we need art at all, it is not in order to be better behaved, better educated (whatever that is), to make better political decisions or even to overthrow tyrants, but in order to be more completely alive.

We need art because we cannot experience our own experiences; or feel that we cannot do so to the high standards set by memory and anticipation – those modes of consciousness that are so

much closer to ideas than is the mêlée of current-account experience, and that within our consciousness create the ideas of what it is that we experience, or what experience should be. We could never attain those standards because the specification for experience outlined in ideas is at once too vague and too precise: from this perspective, the taste of beer is unsatisfactory not for some remediable cause (such as that it is too vinegary) but for the irremediable reason that it does not correspond to the idea of beer.

Ideas have immense scope and at the same time they are uninhabitable; ordinary experiences – even pleasurable experiences sought for their own sake – are socketted in the parish of the moment but have the saving grace of solidity, of actuality, of being of things that are outside of, and so transcend, ourselves. Art mediates between the two, enabling us *to experience ideas* – whether they are ideas in the narrow formal sense of abstract propositions, or whether they are ideas in the wider sense of the notions served up through memory and anticipation. This is the essence of beauty in art; for beauty is, as I have said, a tor on the plain of consciousness.

Through the mediation of form, of connectedness, great stretches of our experience and knowledge are unified into something as great as the immensities sketched in ideas: we rise above our lives to a high viewpoint upon them. This effect of art has been powerfully expressed by Flaubert:

> When I reach the crest of one of his [Shakespeare's] works, I feel that I am high on a mountain: everything disappears, everything appears. I am no longer a man, I am an *eye*. New horizons loom, perspectives extend to infinity. I forget that I have been living like other men in the barely discernible hovels below, that I have been drinking from all those distant rivers that appear

smaller than brooks, that I have participated in the con-
fusion of the anthill.

We become as great as the notions that taunt our experience with
insufficiency. The experience of art thus answers to our desire really
to *be* where we are, to coincide with ourselves.

If there is one constant in the history of art, it is the function
of art as *the great mediator*: between man and God; between man and
nature; between the individual and society. But the greatest and
most profound of its mediations – and the one that underlies the
others – may be within us, between ideas and experience. This is the
sense in which art has assumed the mantle of religion in a secular
society. Beneath the common concern with the ultimate ends of life
there are, however, important differences. Art does not import into
life the burdens of duty that religion does: for example, the duty to
acknowledge and dedicate one's life to one's Maker. And while art
is metaphysical in function, it does not have the metaphysical – the
transcendental cognitive – content of religion. It does not offer the
terror and the comfort of the traditional doctrines about this world.
But it is difficult to mourn these differences of art as limitations.

We need art, then, in order to address the most intimate
tragedy of human consciousness – that of never having been quite
there; to provide a temporary cure for *l'imperfection incurable dans
l'essence même du présent*; to offer intermittent relief of our permanent
condition of never having arrived. We know that in actual life we
cannot arrive. And yet again and again we surprise this hunger for
arrival, for more mindfulness in ourselves. Arrival in this sense is at
least as important as education or preaching or politics or all the
other things that art does so badly and other things do so much
better. Art is useless: as Sartre pointed out, 'the world can very well
do without literature. But it can do without man still better.' Useless

and necessary, art, like holidays, is about experience for its own sake – but, unlike holidays, such experience perfected. So let there be art, rounding off the sense of the world, celebrating the wonderful and beautiful uselessness of human consciousness. Let walking know and perfect itself in dancing.

The Arts and Freedom
Raymond Tallis with Julian Spalding

According to the *aficionados* of neuroaesthetics, we can best understand our experience of art by treating it as a collection of stimuli to which our brains are attuned by nature to respond with particular intensity. Neuroscience therefore holds the key to the effect that paintings, literature and music have upon us. The most appropriate tools to investigate this impact are instruments such as functional magnetic resonance imaging (fMRI) and electro-encephalography (EEG) which show which bits of the brain artworks activate. To understand the difference between Malevich and Matisse we need only to realise that they stimulate different visual pathways; to see why certain lines of poetry move us, we should look for neural structures that are preferentially activated by particular linguistic tricks; and for insights into the reason great music thrills us, it is sufficient to note that they tickle up 'reward' centres in the brain that we have inherited from our beastly ancestors.

Biologically reductive aesthetics does not stop there. Since the brain is an evolved organ, the servant of organic survival, neural interpretations of the arts dovetail with Darwinian explanations that

see literature, the plastic arts and music as forms of behaviour whose ultimate significance is that they optimise the chances of genes replicating themselves. Artists are peacocks attracting mates by showing off; and art itself has the function of promoting social cohesion or conveying crucial information of survival value. Our tastes were formed when our brains had their last big makeover, in the Pleistocene era or, according to some, even before *Homo sapiens* emerged on the scene, being inherited from our pre-human ancestors. We like landscapes that portray good places to hunt, enjoy Mondrian (a favourite of biologisers) because his grids replicate the patterns of light and shade on the jungle floor, and Picasso excites us because his paintings replicate the kinds of 'hyperstimuli'of red dots on beaks that turn on herring-gull chicks.

There are many reasons why this is misguided. Works of art are not mere stimuli to which we passively respond – we actively engage with them. Our responses – including indifference or hostility – are dependent on our attitudes and expectations, in turn influenced by history and culture and our own private history. This is evident from the radical differences in taste evident between historical periods, social groups and individuals. Neuroevolutionary 'explanations' of works of art say nothing about the difference between great art and mediocrity, between different kinds of great art, or about the special truths that art expresses. They can't even distinguish the experiences associated with art from those associated with other recreations. We are repeatedly told that arts such as music stimulate the 'reward' centres in the brain and these are the same as those stimulated by drugs and sex. Through the lens of Darwinised neuroscience, hearing an organ played is no different from having someone play with your organs; and listening to the St Matthew Passion is like a hit of coke. The explanation of artists as show-offs misses out the need for talent, and ignores the fact that

many artists, both male and (increasingly) female, are less interested in attracting mates than in the joys of creation: there are easier ways of pulling than writing fiendishly difficult string quartets.

There is, however, a much more interesting reason why the reduction of the creation and experience of art to biological phenomena is wrong – namely, that it overlooks the relationship between art and that freedom which is unique to human beings, who more than any other living creatures have broken the stranglehold of the material environment. That we live in a shared world woven out of meant meanings unknown to other animals, in a semiosphere and technosphere remote from the biosphere, is adequate evidence of this. Art celebrates and italicises that freedom. Let us illustrate this first by thinking about painting.

Vision is the freest of the senses. When we look at what is around us, we encounter it without being engulfed by, immersed in or directly exposed to it. We are linked to the world but uncoupled from it. We can choose what we see: we re-direct our gaze, or move to another place, or adopt a more favourable position. Our viewpoint, unlike that of the tactile groper or the sniffer, is a vantage point – and not solely for this reason. What we see is much greater than ourselves, not to speak of the eye that sees: *'opsis'* is synopsis. Our heads elevated on our shoulders are little tors. Thus the freedom of the looker; or, rather of the onlooker.

In everyday life, we usually have a particular purpose in looking: the scene demands something of us, or it looks back at us and we have to respond. Our freedom as lookers is compromised; but there is always the possibility of looking for its own sake. Interested but disinterested looking is a primordial recreation. The joy, the power, the freedom, of the spectator is a pre-condition of the enjoyment of visual art. It is not, of course, sufficient; otherwise art would be unnecessary. So what do paintings bring in addition?

Let us examine this through that art which we most con-
sciously associate with the celebration of the human and the expres-
sion of the freedom that is implicit in depiction: the art of the
humanist Europe, the Islamic Middle East and Confucian China.
Among their most popular subjects are landscapes and portraits.
What do these add to the synoptic view available to the unmediated
gaze of the onlooker? The painting gathers what is seen into a rec-
tangle and makes it portable. When the landscape is captured on
canvas, condensed on to a page or brushed on a scroll, it is frozen
in one of its moments, and brought indoors; then the distance
between the seeing eye and the material world is widened. Courtesy
of the painting, I do not have to be in the actual landscape or near it
in order to view it. This is also true of the portrait, where I can look
without being close to the portrayed individual, and without run-
ning the risk of being gazed at in return. The eyes of the subject look
back at us only insofar as we wish, or imagine, them to be doing so.
We enjoy the impression that the eyes of the Doge seem to follow us
round the room because we know that they do not. The painted face
is a pure object of our gaze: it does not in turn make us an object.
Our response to what we see is not fraught with responsibility; our
engagement is a more profound manifestation of the disengaged
state of man, the uniquely uncoupled animal, of the freedom of the
human onlooker. The light is enjoyed for its own sake, not for what
it usefully reveals, objects for the colours of their surfaces.

There are additional features which underline the possibility,
implicit in *opsis*, of becoming synopsis, and it is in these that we find
clues to the distinction between competence and greatness. The
great landscape artist can find the viewpoint that maximises the
sense of vantage point, can deepen the field of vision by playing with
the relationship between foreground, middle ground and back-
ground, by identifying archetypes of light and shade, and by creating

a sense of form that binds the components of the scene more closely together than in the thrown-togetherness, the accidental aggregation, of the ordinary scene. The portraitist may capture a certain expression, which can signify another kind of landscape – the inner landscape that is whatever corresponds to the self. The face may be the token of a type, of a milieu, a culture, a world folded up in the narrative of a life. To gaze at such a face is to see the visible surface of an invisible reality: we are as it were located on a vantage point on an imagined landscape, folded up in the world that is summarised in the sitter's face and body and posture and mode of dress. The greatness of great art lies in the ability to exploit, play with, all of these features, in such a way that uses established techniques and develops, transcends or transgresses them to surprise the eye, so that what is seen is not reduced to a mere picture in virtue of the familiarity of its procedures.

We can think about the other arts in analogous way. The spectatorial joy of the onlooker is explicitly and literally present in drama where we are witnesses to the unfolding of a history. The succession of events and the use of words (dialogue, prologue, chorus) give *opsis* a temporal depth. It is drama, above all, that mobilises another aspect of our freedom – our capacity to play with those things that we on other occasions suffer; to warm our hands before flames that in reality may consume us. We rehearse imaginary situations; we voluntarily undergo those ordeals we fear; we cultivate those emotions that are usually associated with them for their own sake. In comedy we laugh at the world that always threatens to look at us with laughter; or disarm that which frightens us. Literature creates a vantage point from which we view worlds, lives, events, that demand nothing of us other than fascinated and reflective attention. The story that links the beginning and the end, that binds so much together, makes successive happenings to some degree

co-present: beginning, middle and end are pregnant with one another, so that our gaze is expanded beyond the present.

This gaze may be further enhanced by ascribing synoptic glances to characters. The ending of Richard Powers's novel *Generosity* (2009) may stand for countless other instances:

> On the phone the next morning, Thomas Kurton tells Thassa to pick a meeting spot anywhere in the city. [The city is Chicago.] She laughs at the blank check. This city has forests in the northwest big enough to get lost in. To the south black neighbourhoods the size of Constantine that white people never enter. Convention centers with the look of fifties science-fiction space colonies. Warehouse districts full of resale contraband peppered with refrigerated corpses. Cemeteries a hundred times the length of a soccer pitch, with gravestones in forty-one languages. There's Chinatown, Greek Town, Bucktown, Boystown, Little Italy, Little Seoul, little Mexico, little Palestine, little Assyria . . . Two Arab neighborhoods – the southwest Muslims and the northwest Christians – where people from a dozen countries congregate to eat, recite Arabic poetry, and mock one another's dialects.

Poetry, too, aspires to open up a space corresponding to a hugely expanded gaze and it does so by packing much into a small compass and thereby exploiting most directly the capacity of words to transport us to a bird's eye view, or to construct out of a succession of viewpoints the rising storeys of a vantage point that lie beyond the scope of any eye. Lyric poetry (the quintessence of the poetic art) aims most obviously to unpeel a part of what is there, to make something truly present, lit by a fixed and steady gaze. It fastens our atten-

tion by articulating an ideal attention. But, beyond its explicit theme and occasion, it delivers a wider slice of the world through the nimbus of the unsaid in which it encloses the said, a remembered world picked out in hints, a space of meaning whose ante-room is signalled by the whiteness that surrounds and permeates the poem's verbal thrift – the emphatic hush of the wide margin and the space between the lines. The poem is *gedichte* ('condensed', to use the lovely German word for a poem), gathering and connecting a large field of implied sense in a few words, thus making it *mind-portable*. It underlines the connections it invokes by virtue of its own internal connectedness. This goes deeper than a logically organised sequence of meanings and is secured by the rhythm – and other modes of internal stitching – and the sound of its words. A poem, Paul Valéry said – and he meant a lyric poem – hesitates between sound and sense; and this verbal *impasto*, thickening the physical presence of the words that convey meaning, adds viscosity, a necessary brake on the unidirectional succession of moments that characterises prattle. The very complexity of poetry says stop, slow down. The arresting and difficult metaphor puts a brake on two kinds of hurry: on the flow of language; and on the swivelling gaze that is forever moving on. Gottfried Benn described his last poems as *Statische Gedichte*: poems that stand still. But there is something in much great poetry that stands still, that tries to fuse journey with arrival, which enables escape from fluency.

Slowed, we are invited to expand into the mental space words permit and we may take this further. Think how often poetry incorporates lists of disparate items, inviting us to construct a space corresponding to that which is triangulated between them. Consider this stanza from the poem 'Legend' by Boris Pasternak (it is one of Zhivago's poems):

Eyelids tightly closed,
Fords, rivers and streams.
Cloudy height of the heavens
And ages, and years . . .

The gaze is extended to include the dreams of a child on the verge of sleep, and the world he imagines around his closed eyelids, bringing together that remote past, the nursery past of all of us, with the shared past of history, of the legendary, and the years between our early past and the present. Thus is the freedom of the gaze enhanced by literary art that not only liberates us from the residual responsibility of any onlooker, who is located in that which is looked upon, but also hugely amplifies the field of vision.

We are invited, when we listen to a story, or read a novel, to *envisage* the events or scene that is presented to us. This invitation, and the story itself, is built upon the primordial freedom of the onlooker, of one who knows but does not have to act on knowledge, who is *uncoupled* from that which is revealed to him. It is this that connects the reader of the most sophisticated novel with the pre-historic *flâneur* looking for no other sake than that of seeing, for the pleasure of contemplation.

The joy of celebrating the freedom of the onlooker, who is not *obliged* to look, is evident early in life, when we create visual surprises for each other, ur-stories of concealment and revelation, of hide, seek and find. One of the earliest recreations is the game of peep-bo, which can keep an infant entertained for longer than most parents can stand. Visual suspense is created by the disappearance of the mother's head and its return is awaited. This sequence of departure, waiting and return, shares a fundamental characteristic with the tale, where a beginning creates the basis for a middle that sets up the need for the resolution provided by the awaited end. The storyteller's art, which exploits this basic structure, but (*pace* the

primitivisers) transforms it out of all recognition, lies in the cunning with which he or she makes the audience aware of a withheld fact (or set of facts) and whips up the appetite for it (or them). It is central to our thesis that this appetite is one that is chosen and quite unlike the biologically prescribed ones that have to be satisfied on pain of suffering or death. The curiosity of the onlooker and of the listener to a story – or a joke – are analogous expressions of a fundamental freedom that may have once had its roots in biological necessity but have long since left it behind.

The creation of new appetites to be satisfied, of desires to be fulfilled, as an expression or celebration of a fundamental human freedom, is most clearly evident in music. This art is most remote from vision (except in the case of mixed forms such as opera) and might consequently seem most difficult to enfold into our thesis. The different freedoms of the composer, the instrumentalist and the listener are, however, deeply connected with that freedom that begins with the onlooker.

When I look for the sake of looking, the series of visual experiences I enjoy – which experiences and in what order – lies within my discretion. I look over there and note the sunlight on the trees. I look a little closer and see the insect crawling over the sunlit stone. I look closer still and observe the sun on my hand. The sequence of events is not a causal sequence: there is no law of nature that prescribes what shall follow when I, as it were, flit between causal sequences, alighting upon this one and that, like a butterfly. I can do this, as if from outside of the material world of which I, and my eye, are a part, because the intentionality or aboutness of perception are outside of the causally closed material world. Let us dwell on this for a moment, for clarification.

When I look and see something, this is because light from the object enters my eye and (presumably) tickles up my brain causing the nerve fibres in my visual pathways to be activated. How the

light gets in, however, is only half the story. The other half (equally important but tending to be overlooked, especially by materialist philosophers and those who would biologise humanity) is how the gaze then looks out. The outward-looking gaze is always implicitly active, rowing against the tide of causation; but it is ripe to be made explicitly active as when slack-jawed gawping is replaced by scanning, observing, scrutinising, peering, systematic surveying. The gaze is not part of the causal network into which the body of the onlooker is stitched; indeed, it represents a tear in the causally closed material world; it is the basis of the onlooker's freedom.

At this stage in the argument, an inchoate objection may surface. Humans, you might say, are not unique in having vision and, what is more, the visual range and acuity of some animals are more impressive than ours. This, however, is to miss an important point: it overlooks the unique context of vision in humans. The human onlooker is not just an organism: we are embodied subjects, consciously offset from the world with which we interact, bearers of temporally deep selves, leading our lives, not merely (organically) living them from tenseless moment to tenseless moment. We are subjects facing objects, acknowledged as transcending our experience of them, selves interacting with worlds and not just biological entities pinballing through material environments. It is this that makes the merely potential freedom of the animal gaze something that in us is realised as true self-expressive freedom. The freedom expressed in the elective experiences of the (human) onlooker is predicated on a self in whom they are embedded as part of a consciously lived life.

The artist not only celebrates this freedom but takes it further. In ordinary experience, the contents of a scene are served up as givens and, what is more, there remains the possibility that the onlooker may be required to respond practically to what he sees.

The artist, by contrast, can pick and choose his elements and can, within limits, arrange what is on the canvas, according to his wishes. No landscape open to the eye looks like the arrested landscapes seen in a frame, and not just because the latter have been translated to the flat surface of a canvas, framed, and transported to be hung in a gallery, notwithstanding that painted landscapes alter the way we look at those that simply happen, and influence those we choose to seek out and look at. (Pictures help to define our sense of the picturesque.) And, as we have already remarked, both artist and viewer are free from the obligation to respond to what is in the landscape with anything other than pleasure – the pleasure of aesthetic satisfaction in which memory and emotion and a sense of form and admiration at the artist's skill and originality are mixed. The viewer can roam over the picture at will, alighting on this, that and the other, in pursuit of an overall sense of what is before him.

What then is the relevance of this to music? First of all, music is sound hearkened to for its own sake, as paintings offer us sights for their own sake. Listening to it does not serve a particular purpose, as it does when we listen out for the tread of an oncoming predator (or vehicle), or for the cry of a baby, or for the summons of someone who wishes to communicate with us. This is the freedom of the 'on-listener', the acoustic *flâneur*. Secondly, music creates an appetite for a resolution that it will itself provide. This is the narrative dimension it shares with literature that also unfolds in time. Thirdly, and incidentally, it may prompt other activities that are undertaken for their own sake, as an expression of our freedom – dancing (in which we move not in order to get somewhere but simply to enjoy rhythmic movement singly or as a mode of being or coming closer to being together) or singing (in which we vocalise not in order to communicate something of use but to share the pleasure of the human voice, as another way of 'togethering'). But

most importantly music illustrates something that is only embry-
onically developed in the case of the onlooker: the ability to put
together a succession of events that relate to one another in a way
that is not dictated by the material world. The butterfly-onlooker,
alighting here and there on the given, and thereby creating a unique
succession of visual experiences, is taken further. For the very
elements of music, the constituent notes, are not prescribed by
the material world or borrowed from the domain of practical dis-
course. Not only the notes, but also the way they are organised, are
freely chosen. This touches on something at the very heart of human
freedom.

I am listening to someone playing the piano. The means by
which the sounds are produced are an expression of the usual causal
mechanisms in the material world. The keys are struck and this
causes the hammers to move. The moving hammers hit the strings
and this makes them vibrate. The vibrating strings cause the air
around them to vibrate in turn. The vibrating air causes my outer
ear to vibrate in sympathy and this is transmitted by further causal
mechanisms to my inner ear where the energy is translated into
nerve impulses that eventually reach my auditory cortex. That is one
sequence of events, linking the notes played to my hearing them,
and it is matched by events occurring throughout the biosphere,
when animals hear sounds betraying the presence of predators or
prey or communicate with one another. But there is another
sequence of events which are linked in a different way: this is the
sequence of notes that adds up to the piece we are hearing. This pas-
sage from musical moment to musical moment is not governed by
material causation but by the rules of composition, the sense of what
goes harmonically with what, by a feeling for consonance or for
strategic dissonance, by an unfolding narrative of expectation and
fulfilment or of surprise. Sound enjoyed for its own sake is shaped

to create harmonies, unknown to nature, which satisfy appetites or needs that have been cultivated in order to be enjoyed. They are entirely and gloriously superfluous.

Music is a particularly striking illustration of the connection between art and freedom because its elements are not served up by nature. Tunes are woven out of manufactured sounds that are then connected and collected together in a way which does not reflect naturally occurring physical arrays. They have an inner dynamic, a narrative that has nothing to do with the unfolding of events in the material world, and express meanings that are lifted up from those that are imposed upon us by the laws of material causation. These meanings are achieved without precise reference: their free-floating significance – untethered to particulars – corresponds to emotions which change the way we experience the world as a whole rather than some item in it. We could turn on its head Martin Heidegger's claim that emotions are a mode of attunement to the world and say that tunes bring us into emotional relationship with the world. This, at any rate, is why, when we discuss music – other than in terms of technique – it is valid to use the language of emotions, although admittedly it is also sometimes because we lack language precise enough to articulate what music expresses to us.

Music illustrates in the highest degree that expression of freedom whereby we cultivate for their own sake things that would otherwise happen to us unbidden, that are enjoyed rather than suffered in response to uninvited events. Emotions serve their purpose in everyday life: they underline the reality of what is before us but they are curdled and confused – by other emotions and by the talk (within and around) in which they are narrated, justified, explained, and the actions they demand of us. In music, we get emotions purified of prescribed narratives, untethered from any pressing reality. We get the sadness of loss without loss, the sensation of terror with-

out any object of terror to which we have to respond, the luminescence of joy unattached to an object that melts away even as we perceive it. In a sense, musical emotions are irresponsible and that is why, though they may be more direct and intense, they are not superior to the emotions awoken by, say, poetry. Wordsworth's 'emotion recollected in tranquillity' is just as valid an expression of our freedom to cultivate for their own sake things that on other occasions serve a useful purpose. Of course emotion in music is unlike the raw stuff of everyday feelings in other respects: the sadness of a slow movement is not contaminated with tears that make cosmetics run and mucus flow; and it has its own exquisite architecture, conferring a structure, even a narrative structure, on the evolution of feelings. And at times it brings emotion closer to thought; as Felix Mendelssohn said, 'The thoughts expressed to me by music are not too indefinite to be put into words, but, on the contrary, too definite.'

Art and the promotion of freedom

Many artists, perhaps not always the greatest, feel that they should seek to try to change those things that prevent others from enjoying the primordial freedom that is made possible by the human condition – to amend the lifelong destitution experienced by so many resulting from the injustices maintained by despots ranging from domestic tyrants, to village elders, to blood-boltered kleptocrats holding entire peoples in subjection. Art, they argue, should not only acknowledge that many humans are enslaved by want and by other humans but should commit itself to changing this iniquitous state of affairs. This *Kunstlerschuld* is honourable but mistaken.

Yes, artists should be concerned with the freedom of those who are not free to enjoy art or, indeed, with the freedom of those artists who are prevented from expressing themselves freely. That

is not in question: it is the duty of all decent human beings to promote the freedom of their fellows. What is in question is whether they should seek to do so through their art. James Joyce was explicitly, passionately non-political. *Ulysses* – his extraordinary reconstruction of a day in Dublin as experienced through a variety of characters, and mapped on to the earliest great work of Western literature, *The Odyssey* – was a gigantic celebration of the complexity of human consciousness, of the infinite richness of language, and of the endless multiplicity of the world. At the same time, it was absolutely fearless. Swearing, blasphemy and irreverence bring us close to the private, unspoken, truth of the world. They thereby subvert the kind of calculated, constrained public discourse that held Ireland paralysed in the gaze of a repressive church in pathological collusion with a political class whose corruption was well served by the culture of silence and servility fostered by organised religion. *Ulysses* – read by many in secret – must have been empowering in virtue of the space of truth it held open outside of the convenient mendacity of a semi-theocratic state.

When Leopold Bloom blames the flatus he has just passed on the poor-quality cider he has drunk at the same time as he reads out the strap-line below Robert Emmet's statue – 'When my country takes her place among the nations of the earth, then and not till then, let my epitaph be written' (something all children learned to recite in order to inculcate gratitude in them for the subservient condition in which many lived after their country was granted its independence) – more than wind is liberated. Of course Joyce's impact was not immediate; nor did he aim for any kind of impact. He was working upstream, exercising the freedom of an artist to build on the essential freedom of human consciousness. If artists have a political effect, it is by being non-political in the sense of looking outside the cognitive framework within which politics that

brings about change or prevents it operates. They may render visible otherwise invisible assumptions that have made tyrants acceptable or unchallengeable.

The corollary of this is that, since art does little directly to address the suffering in the world, it has to be of the highest quality to justify its existence or to justify the life of the well-fed, comfortable, healthy individual who has the leisure and freedom to produce it. Mediocre art has no place in a world where (for example) 800 million people go to bed most nights hungry and the daily toll of death from starvation is many times more than the number killed in the 9/11 attack on the World Trade Center. Only works that expand the sense of human possibility, of how the world may be seen, heard or understood, can justify the seeming indifference of the artist – an indifference that encompasses not only remediable human suffering but also the fact that most people have lived without what is deemed to be great art and, for most of the remainder, great art has only an intermittent and probably not very important presence in their lives.

An important role of art criticism is to disabuse of their self-flattering illusions those untalented artists who mistakenly believe that they are able to extend the freedom of others. The critic should encourage them to devote their working lives to useful labour (bricklaying, medicine, effective administration) and their hours of leisure to enjoying the art of others. It should also liberate those for whom art is important from the obligation to admire aggressively marketed mediocrity that plays on the fears we all have of being wrong-footed by genuine originality and dismiss it as worthless. Meanwhile, we should acknowledge that any instrumentalisation of art traduces its primordial freedom. If art does bring about change, it does not do so by working within the unquestioned assumptions and the custom-staled vision upon which party politics or collective action properly works.

The freedom of art

The relationship between art and freedom has become more complex of late. Artists are conscious that they enter a field of human endeavour which has a history that is long, varied and often glorious. The nightmare of this history weighs down on them and evokes unhappy feelings. If they have insight into their own limitations, they feel dwarfed by their precursors or have an uneasy sense that there is nothing more to be said or, even if this is not true, that the more to be said is superfluous given that so much has been said already. They are faced also with an audience in thrall to the tastes formed by the techniques and achievements of past masters. A more recent, canny approach, for many artists who cannot measure up to what has already been achieved, is to make a virtue of defeat. They reject the great achievements of the past, arguing that, far from extending human freedom, past masters colluded with the powerful, giving an aesthetic gloss to the ideology that permits the oppressors to continue their evil work of oppression. As a correlative of this, they have imposed their own definitions of 'greatness' on art, determining a canon of masterpieces and the rules of good taste.

It is this latter strategy, of presenting the past as a malign influence, that seems to have achieved increasing prevalence over the last century or so, even among the small minority of self-styled artists who actually have talent. Serious literature – books that are read about at least as much as they are read, as opposed to books that are read without official comment – for a while embraced the anti-, the meta-, the ironical, almost to the exclusion to everything else: it turned in on itself to question its existential validity. Classically trained composers, in the reduced space made available by the expanding presence of popular music and jazz, attacked harmony, melody, consonance, the orchestra and even musical sound itself: vacuum cleaners and silence took their place in the orchestra pit alongside violins and chords. These phases of self-destruction in

literature and music seem to have passed. In the visual arts, however, the illness is still at its height. The onlooker is dismissed and the relationship between the visual arts and vision is either rejected (Duchamp's endlessly applauded contempt for 'retinal' art) or subordinated to the word – as in the case of didactic videos, installations and conceptual pieces that are merely illustrations of (often jejune) ideas more clearly expressed in the explanatory notes.

Much of this work is worthless and greeted with a shrug of the shoulder by most of those outside the magic circle of the mutually affirming in-crowd. Its dominance is at first sight puzzling. The puzzle is, however, soluble. In part, the work exploits those anxieties to which I referred earlier, created by exaggerated folk memories of a period when critics, and the public influenced by them, panned what we now recognise to be great art. In fact, this period was extremely brief and the extent to which the recognition of truly great artists was delayed was minimal. Dramatic transformations in painting – the celebration of the phenomenal appearance of things, the cultivation of colour and form for their own sake in abstract art whose model was music – were in fact accepted with almost indecent haste. What is truly at issue is something closer to our present concerns. This is the tension within art, as an expression of freedom, between freedom of expression, the constraints imposed upon the artist by the rules and conventions of the genre, and the further expression of freedom that comes from breaking those rules.

Let us take a sideways look at this second order freedom – art's aspiration towards freedom from its own convention – by focusing on another human activity that celebrates our freedom: competitive sport. This brings us close to our original theme of art as a celebration of our escape from material fate. Sports are rooted in skills necessary for survival taken to a sphere where literal survival is not an issue. In the case of boxing, field and track sports, and hunt-

ing, the connection with an original biological purpose is obvious. But once they become sports, those activities which served necessity are rendered useless: they are enjoyed for their own sake. The day-long pursuit of the inedible fox by the already over-fed is the clearest possible example of the transformation of an activity that bears directly on a fundamental biological need into a *divertissement* in which the prize is not worth the chase. But the appropriation of needful activity into a recreation is just as well illustrated by the pleasure of running around a track in accordance with the closely regulated rules of the game, fleeing not from a predator but from a failure to which one voluntarily exposes oneself, hurling a javelin at a target in which the target is not running food but a number corresponding to a measure of distance.

These are all strictly rule-governed activities. In some cases, the rules are there simply to ensure fairness – so that, for example, everyone runs the same distance and starts at the same time. But in other cases, the aim is to make the goal more difficult, which not only ensures that there is a level playing field, but that the pastime has infinite complexity. This is most obviously true of team games such as cricket, where the book of rules runs to sixty closely typed pages. The rules measure, and celebrate, the distance from the biological origins of the skills being tested – catching, running, striking and so on. Clearly the game would not be enriched by removing the rules, leaving aside the small question of the anarchy that would result.

What art shares with sport is that it, too, turns something essential to survival – experience, emotion, communication – into recreation, a celebration of freedom. This changes its nature completely and underlines the distance between us and the material world. In the case of sport, this distance is increased by the rules, the unnecessary constraints that make the sport what it is. Art, too,

has its rules, creating a sense of expectation that is fulfilled. When those expectations are tired of themselves, there is a reason to break the very rules that direct the flow of elective necessity that leads the eye, the ear or the mind from one element of a work to another. The question of following, respecting, breaking or flouting the rules is admittedly important but there comes a point – reached a long time ago in visual art – where this preoccupation becomes paralysing; where art becomes increasingly turned in on itself, with the work being presented as a work of *art*, and the creator concerned more with the response of the imagined listener or the astounded, shocked, scandalised viewer seen as an unreflective idiot, harbouring taught aesthetic expectations which are ripe to be overturned or confounded. The laudable aim to unpeel the patina of custom from the art-mediated gaze starts to get in the way of the gaze and the expanded view is blocked as the work becomes increasingly about itself: about itself as an exemplar of art, about 'art' and 'the reaction to art'. Self-reference curdles the cornea to a large cataract.

The end-stage is reached when all rules are so regularly broken that their jagged ends are no longer visible and expectations are no longer raised in order to be confounded. The joyful transformation of biological necessity into a recreation that celebrates the primordial freedom of the onlooker *is* lost along with the sense of an unfolding, but chosen, necessity. The situation of the artist who throws off the 'shackles' of form is comparable to that which Immanuel Kant described when he characterised the aspiration to 'pure philosophy':

> The light dove, cleaving the air in her free flight, and feeling its resistance, might imagine that its flight would be still easier in empty space. *Kant, The Critique of Pure Reason, translated by Norman Kemp Smith (London, Macmillan, 1964), p. 47*

But as Joseph Wright ('of Derby', as Londoners arrogantly dubbed him) showed in his great painting *An Experiment on a Bird in an Air-pump* (1768), a bird in a vacuum dies.

To describe this recent development in art as decadent is too flattering, as decadence is a true challenge to the expectations, assumptions and multiple auto-pilots of everyday life. Much 'subversive' contemporary visual art subverts nothing – least of all the expectations of those who proclaim it 'shocking', 'challenging', 'unsettling' as they sip their champagne at the private view (wondering whether this is where the clever money will go next). For a start, it is wrapped in too many wearyingly teasing layers of inverted commas. The freedom to dance is enhanced by the constraint of fetters, as dancing itself requires rules that create movements which correspond to a sense of form. Dancing, unlike jigging, puts the freedom implicit in everyday life, in our very consciousness, into italics as it represents a world we can discern but which requires nothing of us but freely given attention. And we are free *not* to give art any attention. As L. S. Lowry famously said to a young painter who was complaining that no one bought his work, 'Well, no one asked you to paint it.' And we are free not just to not look at art but not to like it, though dozens of art educators would have us believe that it is our duty to do so and, more than that, to respond to art in particular ways. So the prison bars of preconceived opinions begin to close, and young artists naturally rebel against these as they struggle to express their own new experiences of life. There is, in reality, no 'ought' in art, either on the part of the viewer or the creator. In that sense also, art is free, as well as in the sense of floating above material causality.

In short, art is not an anarchic gaggle in which anything goes. A play that isn't well constructed loses people's interest, and closes. Even if the play sustains people's interest by doing something unexpected, it can do so only against the background of expectation. Art

that breaks the rules works only if there are rules to break. Over the last fifty years in the West, this division between the law-breakers (now the Establishment) and the law-sustainers (now the outsiders) has been reduced to a debate between those who believe the rules of art are arbitrary and those who would find some kind of necessity, some natural rightness in them, even to the point of arguing that they reflect something fundamental about the underlying reality of things, about our place in nature, about the sensibility that responds discriminatingly to art. This debate rapidly degenerates into a pillow fight between all sorts of factions claiming to defend causes that have little to do with art: free-market capitalists and anarchists joining forces on one bed attacking socialists and fascists in another unholy alliance on the other. All that leads to is a cloud of feathers.

A freedom that transcends the rules

The rules of art are neither arbitrary nor essential. At any rate, they should not need to be explicit. All buildings take account of the laws of gravity. If they didn't they'd fall down. But a building doesn't have to proclaim this. Gothic architecture defies gravity. Ancient Greek architecture plays games with it. Neither of these great architectural forms is enslaved to the laws of gravity, though both obey them. Their ability to turn their dependence into freedom is what makes them great. No artist wants his audience to look at his finger when he's pointing to the moon, but he has to use his finger to point. As the saying goes, 'the art is to hide the art'. Technical displays by themselves always appear hollow because they focus attention on the method not the meaning, the form not the content, on the supposedly skilful artist not the product of his skill. What makes a work of art something that can take our breath away, challenge the tedium of an all-too-familiar world, and cause us to rejoice in our own ability to be awoken, is always elusive. No one has ever quite been able to

put their finger on what makes a line of Shakespeare, a phrase of Beethoven or a painting of Van Gogh so entrancing and life enhancing. If they could, these works of art would lose their mystery and authority. They'd become grounded, based on a calculation, and cease to be free-floating in our minds, independently glowing, always apart, no matter how vividly they encapsulate actual joys and suffering we have felt in our own lives. The content of art is not just an expression of freedom, but in essence free. We sigh in free recognition of what is true to our condition, even those aspects of it that seem furthest from our primordial freedom.

The problem is that this content, the irreducible, untranslatable meaning of a work of art, cannot be revealed without technique, without laws of construction. In the material world, A follows B according to inescapable laws of physical causation. But in the world where we celebrate the freedom that begins with our gaze, we are free to make successive experiences follow our disengaged interests. This is the root of the 'virtual causality' of art (to borrow a phrase of Roger Scruton's), in which the succession of experiences is based on a sense of significance unfolding to a total or a conclusion in accordance with certain freely adopted laws. To destroy these laws is to destroy the basis of that celebration of freedom that is art. But these very laws have to be invisible if they are not to get in the way of our seeing the unique content of an individual work.

The nature of these laws has been a matter of dispute since Classical times, most obviously in recent centuries in which aesthetics was established as a distinct field of inquiry. To understand them we have to look at their foundations, what they are based upon. Are they based on natural laws or on the harmonies inherent in a quasi-divine creation?

Art exists in the human mind – the materialists and the most devout would agree on this. The mental sphere in which art is

created can be likened to a luminous bubble that is baseless. This bubble has two dimensions: an inner continuum – a sense of significance unfolding – and a containing whole, a total or a conclusion. All the arts have both of these, with different emphases. The still arts of painting and sculpture concentrate on the complete effect, the moment held in time, but the brush marks, compositional arrangements, etc. within them can be read as sequences – as a performance – and these visual journeys, if the artist is any good, bring you back repeatedly, and with enhanced understanding, to the overall effect, making the whole more and more resonant the more you look at it, your eyes returning again and again, as it were, to drink at its spring of feeling. But even in those art forms where the dimension is mainly temporal, as in music or a novel, the feeling you have when the performance comes to an end, or when you put the book down, depends on the ability of the artist to draw the threads together and create a resolution that, for a while, lifts you out of time, into a kind of space, drawing on that shared sphere of existence that is human freedom.

Within these imaginative spheres artists are free to make any decision they want to in order to express their meaning. The overall meaning they are after is always in their minds from the very start, even if only as a very distant, barely glimpsed goal. This 'vision' has to exist because, if it didn't, the artist wouldn't know where to start. A work of art always begins from a point of lift-off, it doesn't grow from a material base. Even when the artist is drawing from nature, what he is painting is an inspiration not a mere cause driving the strokes of the brush or the pen. To realise his vision, to make it clear, the artist has to make countless minute decisions in order to bring about an overall effect that resonates fully with the elusive truth he sensed from the start. There are principles, in this airy architecture, that can help artists build narratives or construct compositions, but

there are no rules that govern what they actually create. These decisions anyway are always too specific, too detailed and too personal to be captured by general rules. Minute changes, too fractional to be measured, can make all the difference, as any artist knows who struggles to create a line of poetry or a painting that fulfils his own idea of perfection.

This is most obviously apparent in a piece of music played by a pianist, where the meaning is given and has to be brought fully to life again. Many can learn to play a piano, by rote, but the tiniest inflections of touch can lift one performance on to a different plane, while another, perhaps technically more exact, remains pedestrian. If this is true of a performer of someone else's work, how more true is it of the creator of the original piece! Rules are too clumsy – like bars ruled on a stave – to govern such hairline decisions. And it's not that these minute decisions are marginal frills on the edge of art. On the contrary, they are essential, central to its very meaning, at its very heart. Whole heavens and hells can lurk in these interstices. A work of art exists, therefore, in the fissures within a numinous sphere. The artist has to be free, to be totally in control over minutiae no one else can reach, in order to realise a vision of a whole.

Rules can only serve as scent lines towards these innumerable, infinitesimal decisions that, if the artist gets them right, provide lift-off. These are the moments when the artist ceases to calculate, to convey what he's learnt beforehand, but feels freshly what it is like to be alive in that instant, enjoying a state of heightened awareness. At such times he feels utterly free and, paradoxically constrained by, his commitment to achieve his end. No one can tell him how to take the next step. At that stage there are no guidelines. He's at sea. The world is fluid, and the potential is endless.

This is why the decisions an artist makes have to be so delicate and so precise; he is giving form to something that is living, and

he has to do it in such a way that does not trap its life, or even worse maim or kill it. Freedom is the atmosphere in which the germ of a feeling/idea (the two cannot be divided in this state of suspended animation) develops into a work of art that appears to have a living quality of its own. It is this living quality that separates a face drawn by Rembrandt and one, say, by Reynolds. Both knew how to draw heads, the relationship of eyes to ears, and chin to brow, and both applied these laws of nature. Both knew where to place the sitter to capture and hold the viewer's attention, and both applied these laws of artistic composition. The differences between their marks are miniscule, but the results are worlds apart. Rembrandt drew an individual troubled by her awareness of the approach of death. Reynolds drew a stereotypical beauty, posing in a charade concocted by an admirer of Michelangelo, a porcelain face with lifeless eyes and no inner depth (he painted better, Blake said, when he was drunk). These two paintings are not separated by rules but by the way in which the freedom they permit is exercised. That is why when you begin to create with the freedom required for art, a horizon of infinite possibilities opens up. The smallest inflection alters the meaning, and the possible variations in forms and therefore in meanings are as infinitely variable as snowflakes in a drift. That is the terrifying freedom of art's landscape, which great artists have the courage to venture into in order to discover new forms of expression which open fresh insights for all of us into what it means to be alive.

This is why no art form, however wondrously realised in the past, and however closely it was identified with an age that is gone, is, in itself, bankrupt, because all forms of art, whether strictly demarcated according to form or operatically melded together, have the potential for an infinity of different modes of realisation. They are stepping stones to freedom. New forms of expression extend

human possibility, they don't replace those that already exist: films don't diminish the potential of the stage drama. The only honourable course for an artist, then, when faced with the eminence of past achievements, is to emulate the greatness of the potentially oppressive but also possibly inspiring precursor, knowing that he has the advantage of being in tune with the *Weltanschauung* of a later generation that those who have gone before could not even imagine. All true art, no matter how much it tries to emulate a past achievement, is new because no two artists are the same – and everyone reveals, to a greater or lesser extent, a unique personality in what they do – and no one can escape their times. We are of our times and have a unique take on them; individuals with a singular trajectory through the world we collectively fashion and maintain.

Newness is not something to be aimed at directly; it becomes apparent naturally, after it has been made. Art is never the product of a calculation; it's always a revelation. No artist with ambition wants to imitate Tolstoy or Titian; still less does he want to be an advance on them, trump them at their own game. What he does want, however, is to be as resonant and profound as them in his own voice in his own time. He can study the artist he most admires as closely as he can, as for example Proust did Ruskin, and use everything he has learnt to help him climb his mountain, but he knows, as soon as he sets off, that it's his mountain, and he is alone on it, and what he's looking for, dreaming of, is the moment when he throws the ropes, axe and even the boots aside, and takes off, floating free, exploring the precipices, pastures and peaks till he can view the mountain as a whole. What he seeks is the freedom of fluid attention. Rules in art do not exist to be obeyed or broken, but to melt away, because the artist has to float beyond them into a region that cannot be prescribed. Any attempt to tie art back into rules is like

tethering a bird. In that sense it is simply wrongheaded to try to identify the ingredients that go into making art, to write recipes ensuring masterpieces.

Although it is the details that make all the difference, the greatness in a work of art is to be found not by unpicking its constituent parts, but by describing its overall effect. Most writing about works of art tries to analyse the different elements that go into their construction. At its most banal and tiresome, it picks out the echoes of influences – whose steps the mountaineer is following, his memories of other people's mountains before he begins to climb his own. At its best, it brings you close in to seeing the artist at work, following him as he makes decisions, choosing to go this way or that. But rarely do commentators follow the artist at the crucial moment when she acquires lift-off and becomes inspired. What is even more rarely analysed is the overall effect that, when it is fully realised, makes the artist put down her pen, draw a line under all that she has done, and by doing so lift what she has achieved out of the flow of time, leaving her reader, listener or watcher with the immensely satisfying feeling of having, for a while, fully lived. Freedom is therefore expressed in the form of a work of art, not just in the intangible subtlety of its internal structure and the journey it takes us on but in its wholeness and lasting effect.

Concluding thoughts

We began with vision and the primordial freedom of the onlooker. It is this freedom that art celebrates and, in doing so, greatly extends it. Flaubert, writing about Shakespearean drama, spoke of 'a vastness where the gaze loses itself in dizziness'. This freedom that is the be-all and end-all of art is encapsulated in what E. M. Forster said about *War and Peace*:

After one has read *War and Peace* for a while, great chords begin to sound and we cannot say exactly what struck them. They come from the immense area of Russia, over which episodes and characters have been scattered, from the sum total of bridges and frozen rivers, forests, roads, gardens, fields, which accumulate grandeur and sonority after we have passed them.

Forster goes on to say that it is 'extended over space as well as time, and the sense of space until it terrifies us, is exhilarating, and leaves behind it an effect like music'. It is impossible to resist the famous ending of James Joyce's first masterpiece, the novella *The Dead*, which illustrates with even greater brilliance what is seen in the passage from Richard Powers's *Generosity*. Joyce offers us an epiphany of the size of the world in which we find ourselves, through Ireland encompassed in a glance:

A few light taps on the pane made him turn to the window. It had begun to snow again. He watched sleepily the flakes, silver and dark, falling obliquely against the lamplight. The time had come for him to set out on his journey westward. Yes, the newspapers were right: snow was general all over Ireland. It was falling on every part of the dark central plain, on the treeless hills, falling softly upon the Bog of Allen, softly falling into the dark, mutinous Shannon waves. It was falling, too, upon every part of the lonely churchyard on the hill where Michael Furey lay buried. It lay thickly drifted on the crooked crosses and headstones, on the spears of the little gate, on the barren thorns. His soul swooned slowly as he heard the snow falling faintly, like the descent of their last end, upon the living and the dead.

Given the central connexion between art and a uniquely human freedom, biological explanations of art, appealing to a pre-determined animal nature, are misconceived. Animals are unfree, tethered to their biologically prescribed needs, acting out an organic destiny, merely living their lives rather than leading them. Art puts the freedom implicit in everyday human life into italics. The tendency within *opsis* towards synopsis is released when the eye is freed from specific, focal concerns; then the gaze can be truly as far and as wide as the eye can see. Art is the most developed expression of our ability to gather up, and so shape and even manufacture meaning.

This is a long way from the notion of art as the servant of our genes, or as mere bonbons for Bonobos. If we value this, it is because we are aware, as no other animal is, of our finitude: we know, can envisage, the ending of ourselves. Art's glorious freedom is our response to our entrapment in mortality. Art enables us, when our material needs are met, when we are fed and watered and sheltered, to shed light on and enjoy the extraordinary mystery that is our brief time in the light; when we can look about us before we die.